Peregrine Falcon

Dynamic Carving and Painting Techniques for a New Era

Peregrine Falcon

Dynamic Carving and Painting Techniques for a New Era

Floyd Scholz

PHOTOGRAPHY BY ELLYN SIVIGLIA

FOREWORD BY JOHN W. FITZPATRICK

Published by
STACKPOLE BOOKS
5067 Ritter Road
Mechanicsburg, PA 17055
www.stackpolebooks.com

Printed in the United States of America

10 9 8 7 6 5 4 3 2 1

Cover design by Tessa Sweigart

Cataloging-in-Publication data is on file with the Library of Congress

ISBN 978-0-8117-1406-8

DEDICATION

For Michelle, Christine, and Fernando Antonio.

Living proof that Angels walk among us

CONTENTS

FOREWORD

O f all the world's 10,000 species of birds, none elicits more excitement and awe every time we see it than the peregrine falcon. Coincidentally, the *exact same description* applies to the work of Floyd Scholz, today widely recognized as one of the most talented natural history wood carvers in the world. It is, therefore, altogether fitting that these two awe-inspiring personalities have intertwined in the form of this remarkable book.

Appreciated worldwide as a symbol of power and majesty, and supremely revered by falconers, the peregrine sets the bar for flight speed within the animal kingdom. Some ornithologists long doubted the audacious claim that the peregrine could exceed 200 mph during long, nearly vertical hunting "stoops," but that has now been officially confirmed. While stooping to take food from its skydiving owner, who was plummeting to earth at terminal velocity, a trained falcon was clocked at 242 mph! Peregrines often kill their prey simply through the power generated by these stoops, literally knocking an unsuspecting bird dead or breaking its wings upon impact. With this power, peregrines have the capacity to kill ducks that may even weigh more than the attacker— a rare feat among solo-hunting predators. Such high-profile kills, regularly witnessed by hunters and bird-watchers (especially during fall and spring migrations), explain why the species was long referred to as the "duck hawk."

It is exactly this association between falcon and duck that the extraordinary wood carving featured in this book so exquisitely celebrates. No artist, past or present, other than Floyd Scholz could produce such a complex work. Fittingly, he chose to feature the "Peale's" subspecies of the peregrine falcon. These are the largest and most richly colored of the world's peregrines, breeding along the rocky coasts of the Pacific Ocean from Siberia and the Aleutian Islands south to Vancouver Island. Without a doubt, the dramatic scene Scholz created occurs many times each year as these spectacular dark-gray falcons migrate through the wintering range of green-winged teals.

What a rare privilege indeed to be provided this inside look at the creation of a true masterpiece! These pages reveal something very important about Floyd Scholz. This man is not just a five-time U.S. National Champion wood carver, and not just a winner of a World Master's Best in Show. As important as those world-class achievements are, they are overshadowed by Scholz's passion as a lover of nature and by his generosity in inspiring others around the world to share his love and his vision. It is often said that "magicians never reveal their tricks," but in creating this book Scholz—who certainly qualifies as a magician—defies this adage. In revealing many of his secrets, he explicitly invites and motivates the rest of us to push our own artistic limits just as he continually does in creating his superb works of art.

This perpetual willingness to push himself reflects Scholz's background as a world-class decathlon athlete. Indeed, he missed competing in the 1980 Olympics in Moscow only because of the U.S. boycott of those games. Following this disappointment, Scholz turned more of his attention to nature, and I am proud to say that the Cornell Lab of Ornithology played a role in crystalizing his passions. During the 1980s he volunteered with the Cornell Lab's peregrine falcon breeding program, which was instrumental in the reintroduction program that ultimately led to the remarkable post-DDT recovery of this beloved bird across continental North America. Spending time with peregrine falcons inspired Scholz to turn his attention fully to art, and the world has been the recipient of his genius ever since.

I love the idea that the Cornell Lab holds a special place in Scholz's heart, and that each one of his falcon carvings expresses aspects of behavior that he experienced and fell in love with here in Ithaca. Looking at these works literally takes my breath away. With this exquisite new piece and accompanying book, Scholz accomplishes yet another milestone in his remarkable career.

John W. Fitzpatrick
Louis Agassiz Fuertes Director,
Cornell Laboratory of Ornithology
Ithaca, New York

ACKNOWLEDGMENTS

The author wishes to extend a heartfelt thank you to the following friends and associates who were instrumental in the creation and writing of this book:

First and foremost, to Dr. Robert Rankins for allowing me the privilege of bringing his prized peregrine, Thumper, back to life, and to his family, Kristin, Caitlin, Natalie, Drew Goodwin, and Tate Goodwin.

Thank you, Tom Huntington, my gifted editor and friend whose patient, good-natured hand guided me through this rather complex undertaking. Thanks also to Candi Derr for her invaluable editorial support; Cher Williams of CW Design Solutions for designing the book; Tessa Sweigert for her cover design; and Wendy Reynolds, Caroline Stover, and the rest of the folks at Stackpole Books for all their assistance.

To my dear friend Judith Schnell. What can I say? You and the fine folks at Stackpole Books have helped make magic; you've been there from the beginning. I know the best keeps getting better...

A warm thank you to photographer extraordinaire Ellyn Siviglia! Your formidable talents with a camera are equaled only by your friendship and inspirational warm spirit. I could not have done this without you! I thought it had all ended with the passing of Tad Merrick but, thanks to you, it hasn't.

To my good friend and most worthy contemporary in bird carving, Rich Smoker, for his help and advice with this daunting project.

To my wife Beatriz and our family: Ramon and Evelyn, Helenia and David, Bea and Charles, and Eli and Fernando. You are all loved more than you'll ever know.

To David and Alex, Ramon, and Ana Louisa. You are constant sources of love and amazement.

Thank you to my mother, Muriel, and my Aunt Donna, who provided the spark that ignited a lifelong passion.

To all my friends who contribute so much to the beautiful art of bird carving: Jim Hahn of Jaymes Company, Tony and Jess Alfaro and the staff at Tohickon Glass Eyes, Terry and Christine Rickert of Blue Ribbon Bases, Jim and Pam Krausman, and Walt and Karen Blackmore.

A big thank you to Bruce Laumeister, Elizabeth Small, Jana and Matana Lillie, and the staff at the Bennington Center for the Arts. It's a world-class museum for all to discover.

I was raised by one tough Marine who taught me early on what it means to work hard and take pride in one's accomplishments. Thanks, Dad!

To all the brave veterans, past, present, and future for the unimaginable sacrifices made daily to ensure our freedom.

To Myron and Karin Yanoff: Words like "Thank You" will never seem enough.

To Ron and Nancy Walborn for allowing me a great opportunity all those years ago to begin my journey as a professional bird carver.

Thank you to my friend and mentor Ben Bailar, who, from the very beginning, always believed in me.

To my "brother," Ol' Mossyhead Mark Johnson, who knows how to bring the banjo to life!

Thank you to Ellington, Jeannene, Tyler, and beautiful Larah Darden.

To all my dear and respected Canadian friends: Mary Sinclair; Eric and Vizma Sprott; Renee and Marijka Ballard; Robbie and Annie Evans; Kathy and Neville Taylor; Rob Cudney; Sheldon Inwentash; Chuck Fipke; David Bruce; Warren Irwin; Faye House; and the incomparable Dale Brazao! You all make me wish I, too, were a proud Canadian!

Thank you so much to my good friends at the Central Florida Audubon Birds of Prey Center. Especially Diana Flynt, Katie Warner, Beth Lott, Samantha Little, Matt Smith, Samantha Jackson, and Margaret Spontak!

. . . and always my deepest love to Dick and Dorothy Robson. We've been there, we've done that—and the best has yet to come!

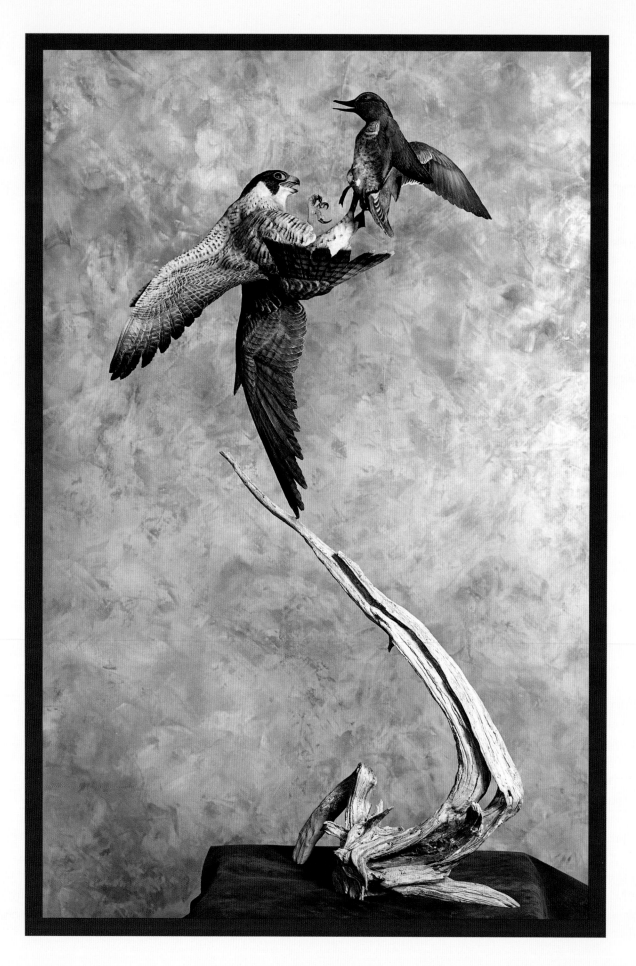

Take the Challenge

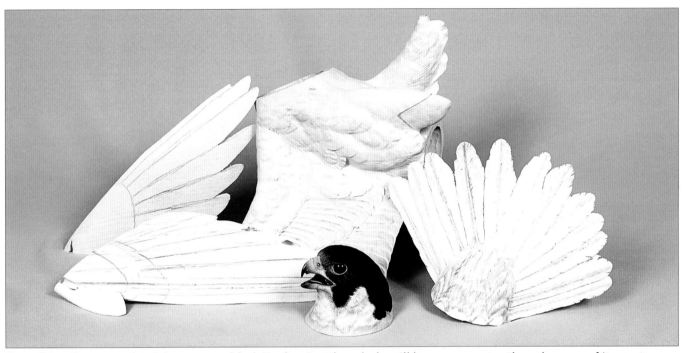

Once I get the peregrine falcon assembled, I'm hoping the whole will be even greater than the sum of its parts.

"I'm nowhere near the end of where I plan to be."

I was digging through a box of old correspondence recently when I came across that statement, something I had scrawled on a piece of paper years ago. The more I thought about it, the more I realized how true those words remain in my personal philosophy.

One thing hasn't changed over my years of bird carving, and that's my commitment to positive change. I've been carving birds out of wood for about 45 years. As a professional artist and instructor, I'm constantly striving to keep my work fresh and exciting by developing new and more efficient ways to carve and paint. Change is essential if you want to grow as an artist. In fact, life itself is about change. Like a good bottle of wine, we should all improve with age—and so should our carving and painting.

I became a professional carver in 1983. Since then I have seen incredible advances in the development and refinement of tools, paints, and procedures, as well as a transformation in the art form itself. The reference materials and tools available today enable the modern woodcarver to create bird sculptures in wood with greater accuracy and detail than ever before. The work some of the world's best carvers were doing 40 years ago would hardly win a ribbon in the amateur class in today's carving competitions.

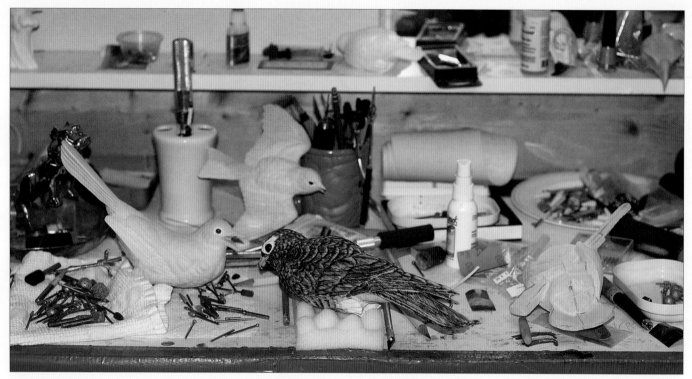

Even though the peregrine falcon provided my main focus during a five-month period, I frequently had several smaller pieces underway at the same time. When you get to a certain point on a big piece it's often a good idea to set it aside from time to time and redirect your energies toward something smaller and simpler.

Years ago, as I began to devote more of my time and focus to developing my skills as a bird carver, certain carvings I would see in magazines or at carving exhibits caught my eye and held my imagination. The works that really had an impact on me were the larger and more elaborate pieces the great carvers of the day were doing. I remember being awestruck by the masterful creations of John Scheeler, William Schultz, Reverend Jack Drake, Lynn Forehand, and of course, Gilbert Maggioni and Grainger McCoy. I used to think, "These guys are putting wooden birds in flight! How cool is that?" The dramatic stories they told through their work moved me deeply and left an impression that remains with me today.

I remember a conversation I had as a teenager with the late Bruce Burk, just after he published his groundbreaking book *Game Bird Carving*. We met at an event he was attending and I told him how much I liked the bigger and more elaborate works featured in his book. "Someday I'd like to get up the courage to tackle something like that," I said. He told me he called those carvings "monumental works" and said he was glad to have provided me with something to strive for.

It was then that my journey began.

I like to think and work in dramatic and big ways, so it is only natural that eagles, hawks, and falcons—including this book's peregrine—have become my favorite subjects. These great birds are so demanding of respect and so powerfully in command of their surroundings, yet hopelessly vulnerable to the destructive whims of mankind. I strive to capture those qualities in wood.

But while bird carving is an art that celebrates nature, it should not be looked upon as nothing more than wooden taxidermy, with a microscopic focus on anatomical detail overshadowing other important factors such as great composition and innovation in design and presentation. As sculptors, we must strive to be story tellers, and I've chosen to tell big stories and communicate the beauty and majesty of birds in their environment. For me, nothing says "supremacy" like a great eagle clutching a jagged branch or rocky cliff as it defiantly stares you down—or a peregrine falcon snatching at a green-winged teal in mid-flight.

That aspect of my work has always remained consistent. I feel I owe it to my students and myself to try and stay "ahead of the curve" by developing new approaches and more efficient ways to achieve my desired results. Over the past five years in particular my own approach to carving any large, highly animated work has gone through a major evolution and I feel the time has come to share it.

As confidence in my abilities has grown, my attitude towards what is possible in transforming a block of wood into a believable, gravity defying sculpture has broadened. I've developed the ability to achieve a lot more with a select few, well-adapted tools. For instance, the safe and proper use of the high quality electric chainsaw has become a mainstay when I carve larger and even mid-sized birds. I now use the Foredom flexible shaft rotary tool with a sanding sleeve mandrel a lot more while feathering and adding body and wing details.

I do more work now to hollow out the walls of the body cavity to extremely thin dimensions to reduce weight. I've turned to less formal base design and configuration, which has led me to a wide array of creative presentations. When painting, I use much more iridescence in my under painting to enhance the vividness of my colors.

You might think this book is merely a demonstration of these techniques as I lead you through the process of designing, carving, and painting a life-size peregrine falcon in flight clutching a hapless green-winged teal. And you might be correct. But it's also something much more.

Consider this book a challenge!

I offer you a bold approach to tackling big, complex sculptures. My hope is that this book will inspire you to challenge yourself and become a better and more adventurous carver. With practice and repetition you will improve, and as you improve, your confidence will grow.

My artistic goal when I tackle one of these big birds is a simple one. I'm successful if the finished work moves viewers emotionally and elicits some positive response as they gaze upon the power and dignity of one of my carved eagles, hawks, or falcons.

The challenge of working continuously on one big piece can be a test. With a big sculpture, weight, balance, and harmony become especially critical and you have to keep these elements in mind at all times. You must also learn to pace yourself and remain realistic about what you can accomplish in any given day. Certain days will be very productive, while others will be full of distractions. This is just how it goes and is part of the process. Keep thinking big and don't be afraid to challenge yourself. You'll be glad you did!

You'll need to take a bold, aggressive approach when you tackle a big, "monumental" work. When roughing out the

A good, powerful dust collector is a must if you do extensive machine work with wood. I have attached this one to my band saw with a 4" flex pipe. It does a great job minimizing the amount of airborne dust from the cutting operation.

basic form of the bird I've started using my small electric chainsaws more and more. In the right hands, an electric chainsaw is a real time saver and frees you up to be more creative as you wrestle the shape from the block. (You must take extreme care, though, and respect for the tool is paramount.)

Once I start carving, I rely more on my various types of holding devices, such as my Hydraulic model 303 Pow-R-Arm vise and my Panavises. These handy implements free up my hands and allow me to position the bird at an earlier stage in the carving process.

One thing I appreciate as I work on these monumental works is that we are carving in an age of unlimited possibilities, with an entire industry that has grown around the art of bird carving and taxidermy.

For example, I've had the good fortune of working closely with my good friend Tony Alfaro at Tohickon in developing their line of incomparable glass eyes. He and his wonderful staff are constantly striving to put out the best product possible. They may be humbled by the realization that perfection is an abstract concept, but they continue to innovate and I must say…they come mighty close!

Abrasives have improved, too, as have cutter bits. The good folks at the Gesswein company in Bridgeport,

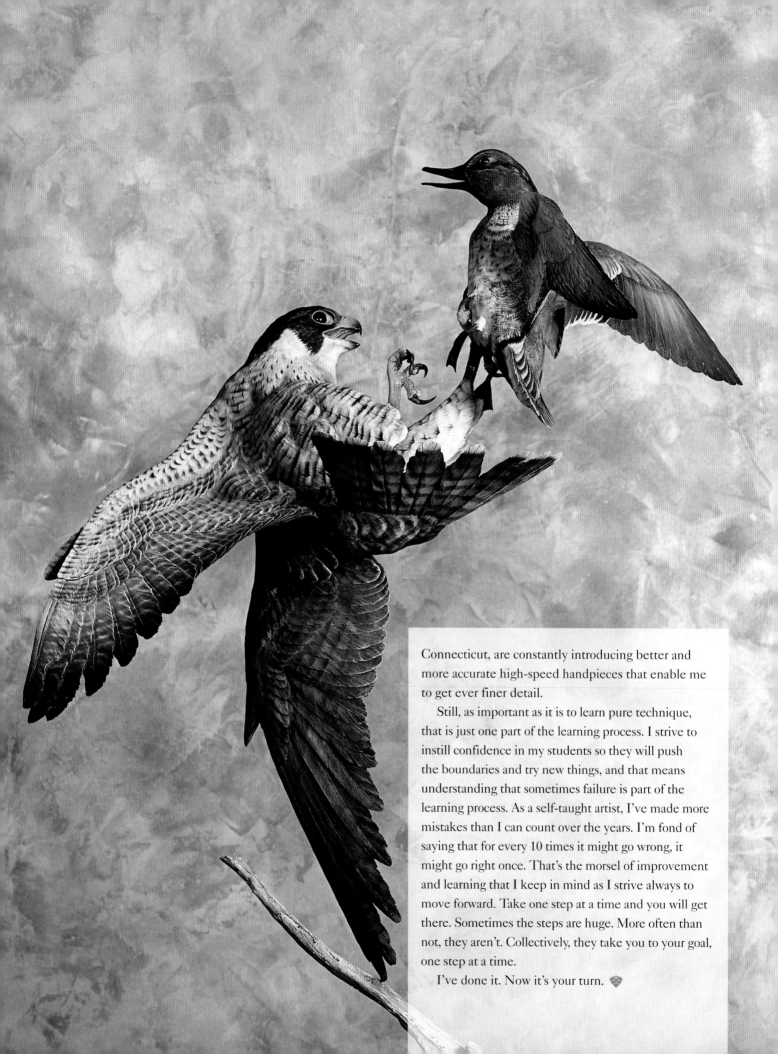

Connecticut, are constantly introducing better and more accurate high-speed handpieces that enable me to get ever finer detail.

Still, as important as it is to learn pure technique, that is just one part of the learning process. I strive to instill confidence in my students so they will push the boundaries and try new things, and that means understanding that sometimes failure is part of the learning process. As a self-taught artist, I've made more mistakes than I can count over the years. I'm fond of saying that for every 10 times it might go wrong, it might go right once. That's the morsel of improvement and learning that I keep in mind as I strive always to move forward. Take one step at a time and you will get there. Sometimes the steps are huge. More often than not, they aren't. Collectively, they take you to your goal, one step at a time.

I've done it. Now it's your turn.

The Peregrine Falcon

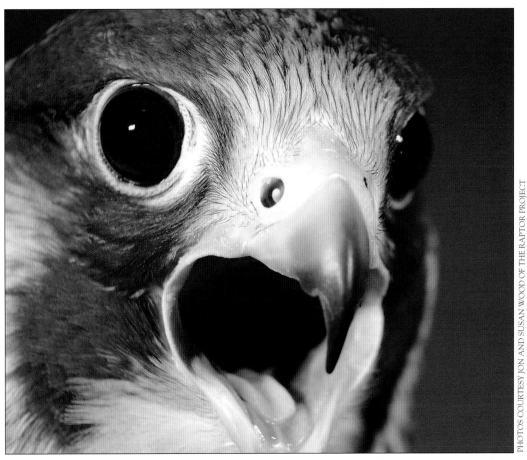

PHOTOS COURTESY JON AND SUSAN WOOD OF THE RAPTOR PROJECT

Form follows function. Adaptations such as baffled nostrils, large, well-protected eyes, and tight feathering are all clearly visible in this close-up of a juvenile peregrine falcon's head. I'm always amazed at the wide gape of any raptor's fully opened mouth. This is a necessary adaptation for birds that use the rip, tear, and swallow method to eat.

I s it possible to truly describe this magnificent creature with mere words? I'm not so sure you can. It probably requires something along the lines of a musical symphony.

The peregrine falcon (*Falco peregrinus*) is a marvel of adaptability and feathered perfection. Watching one of these raptors in flight will leave you speechless. It is a creature so totally in command of its domain, the sky. From the tip of its beak and baffled nostrils, down through its powerful tapered wings that trail off onto its streamlined tail, every nuance of this bird's anatomy cries out SPEED! Researchers have observed peregrines diving at speeds of around 240 mph. Not surprisingly the name "peregrine" derives from the Latin for traveler.

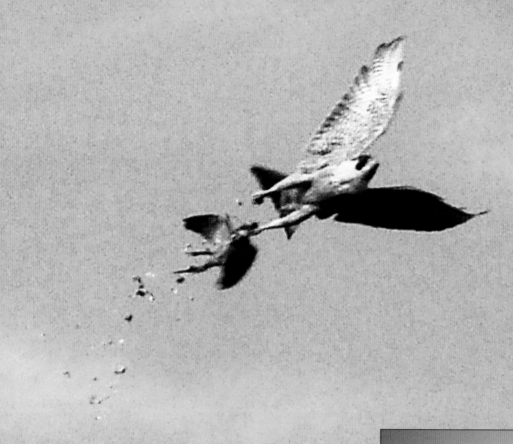

Above: Woe to the bird that a falcon sees as prey. The raptor attacks like a thunderbolt, sometimes killing its target with the force of its initial blow. Right: As if modeling for the peregrine equivalent of a Mr. Universe competition, this fine bird displays the complex and beautiful patterning found throughout the undersides of an adult. Note in particular the staggered length and shape of the primary feathers. This pose would make an inspiring and very powerful sculpture.

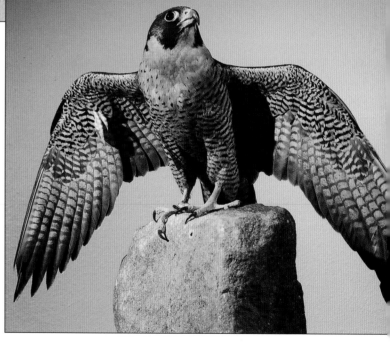

Found all over the world, peregrines have been classified into 18 distinct races with sizes ranging from 12 inches up to and even exceeding 18 inches.

The northern sub-species are highly migratory and seek out tropical or subtropical environments during the cold winter months. Shorelines and open country that provide some sort of elevated, rocky overlooks are their preferred landscapes when it comes to nesting and raising young. During the nesting season the pair, which mate for life, may cover a range of anything from a quarter mile up to 120 square miles depending on the availability of prey.

Peregrines are the most prized of all falcons for hunting. They can be easily caught, tamed, and trained, so people have used them for the sport of falconry for thousands of years.

One of the great success stories in ornithology over the past 40 years is the return of nesting peregrines to the easternmost parts of North America. The Peregrine Fund, based in Boise, Idaho, has been the driving force behind this and many other raptor success stories. If ever you were considering supporting a most worthwhile and worthy environmental organization, this is it. You can find them on the web at *www.peregrinefund.org*.

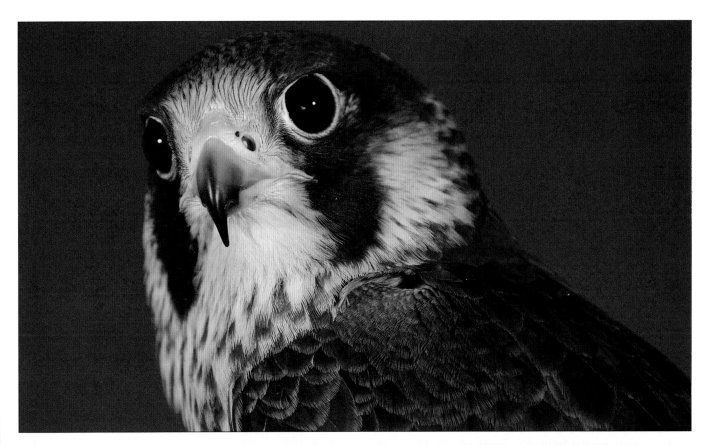

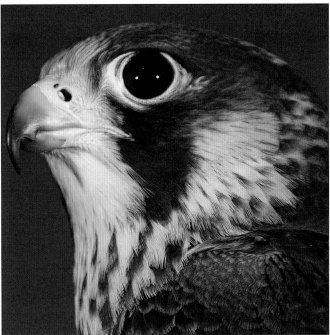
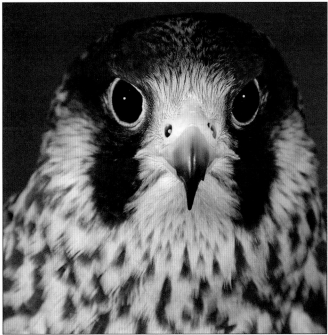

Top: In immature birds the edges of the feathers are much more clearly defined. Many renowned bird artists I've talked with consider the juvenile plumage to be much more attractive than the adult garb. Note the deflection of the throat feathering as the head is turned sharply to the left. Above, left: The compactness of the beak and tight lip line lead your eye back into the large, round dispassionate eye. This bird is in immature plumage, which accounts for the heavily streaked areas on the side of the cheek and lower throat areas. Notice the lack of feathering directly behind the eye ring. Details like this are essential for capturing the right look of a bird like the peregrine falcon. Above, right: This straight-on front view helps illustrate the downward angle of the corners of the mouth. In proportion to the nostrils, the eyes are located a bit higher up in the head than they are in, say, a red-tailed hawk. The white area of the forehead equals the throat area in width when viewed from this angle.

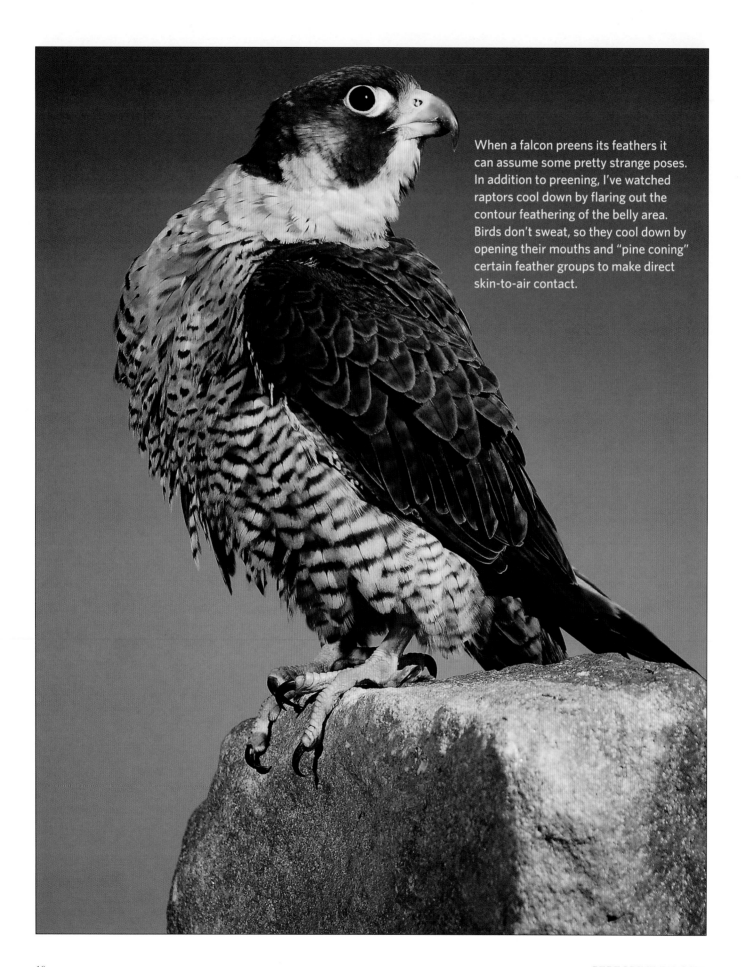

When a falcon preens its feathers it can assume some pretty strange poses. In addition to preening, I've watched raptors cool down by flaring out the contour feathering of the belly area. Birds don't sweat, so they cool down by opening their mouths and "pine coning" certain feather groups to make direct skin-to-air contact.

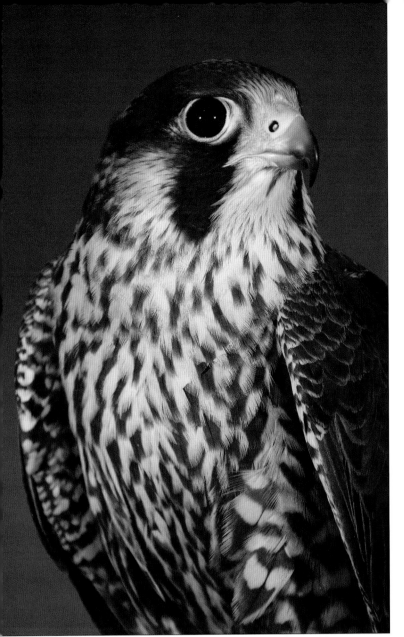

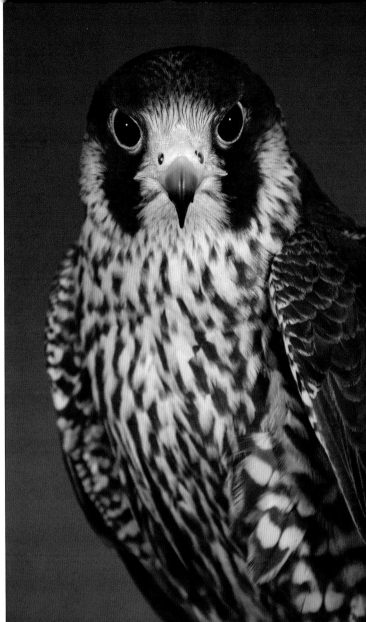

Above, left: I love this photo of a semi-alert young peregrine. At one time it was widely believed that juvenile peregrine birds were a separate species based on their distinctly different plumage patterning and color. This patterning really shows off the strong feather flow of the belly and chest areas leading right up into the head.
Above, right: Here's another nice ¾ front view of a peregrine falcon in immature plumage, showing a perfect straight-on head view.
Right: This close-up view of the face says it all about the fierceness and apparent pride of one of the most efficient and highly evolved of all bird species.

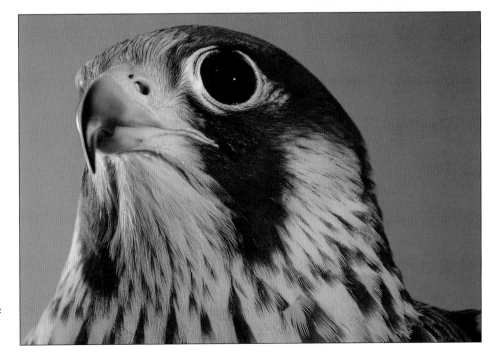

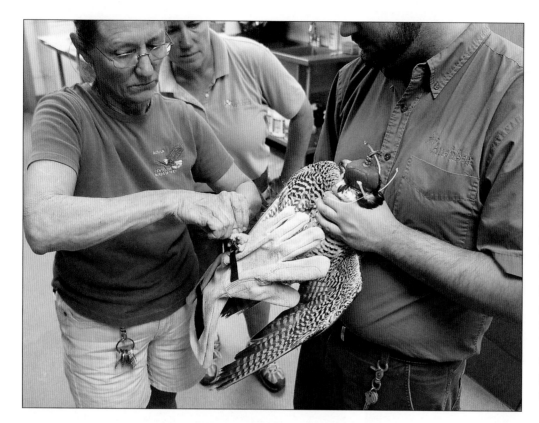

During a visit to a local raptor rehabilitation center near my home, I was able to check the accuracy of my wooden falcon's tail against a live bird. Fortunately for me, the center's staff were in the process of doing health checks on their resident peregrines when I visited. When keeping raptors in captivity, such scheduled health checks are essential for maintaining the health and well-being of the birds. This must be done quickly as the birds can overheat and die of stress. They have no idea you are doing it for their own good. They only see you as a mortal enemy.

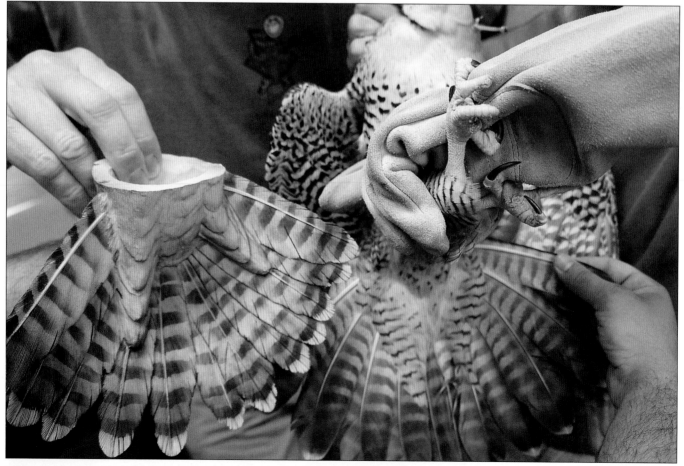

What can be more helpful to an artist than to compare the two side by side?

PEREGRINE FALCON

I also checked the wing size, shape, and feather layout against the real bird.

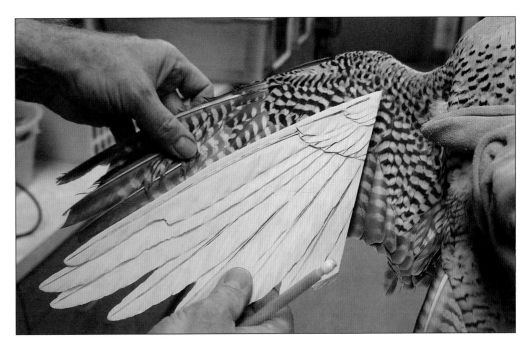

Research is so important to ensure accuracy in areas not often seen when the bird is just sitting on a perch. Here, I'm counting and checking the size and shape of the axillary feathers.

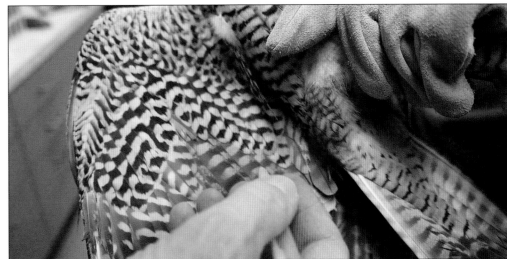

What a beautiful layout of feathers! Notice the subtle shading of soft gray from the outer edge to the front of the wing.

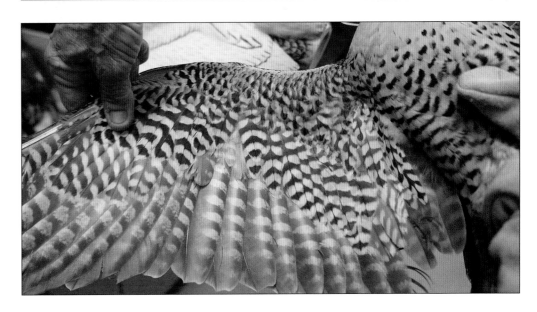

Before Tool Touches Wood

As an artist, you are a storyteller spinning a nonverbal narrative about your subject.

Before you start a project you must study the bird. Learn all you can about its habits and natural history. You certainly wouldn't perch an Atlantic puffin on a cactus, or place a roadrunner on a rock covered with seaweed! Those might be extreme examples, but I think you get the idea.

Most importantly, decide what you want to say about your chosen subject. Where does it live? Why does it look the way it does? What's the bird's mood? Resolve these simple questions within the parameters of your design and composition and you will have gone a long way toward catching and holding the viewer's attention with the completed carving.

In my own work, I try to draw attention to certain characteristics of the bird I'm doing. If it's a red-tailed hawk, then show off the beautiful red tail. Highlight the intensity of an adult goshawk's eyes. Pose your peregrine falcon in a way that says, "I'm the fastest animal ever!" Have some fun, be adventurous and fearless, and, above all, try out ideas no matter how far-fetched they may seem.

For the overall composition, try to achieve balance and harmony. Use elements that will complement but not compete with the bird.

Once you begin to remove wood, you are committing yourself. It's important to have a clear and uncluttered idea of your goals in terms of size, shape, and—even at this early stage—attitude. Experience has taught me that the most important work you do occurs when you rough out the bird's basic form. I like to compare the work to building a house. Paying close attention to the foundation means each subsequent step will go much easier. With carving, careful roughing out of the bird's body is the foundation to an accurate and successful work.

Strive to achieve proper balance in the bird's body by drawing in and maintaining a centerline. A clean, sharp, and clear line drawn in with a pencil is of paramount importance. I try and simplify things in my mind by looking at the form as nothing more than a series of squares and rectangles. As I proceed, I simply round the corners to form a more organic shape. This geometric approach helps ensure accuracy,

symmetry, and balance. You draw as many visual guidelines as possible and use them. If you remove one, immediately redraw it. Proceed slowly and remember the old carpenter's adage: "Measure twice, cut once."

Woodcarving is a subtractive form of sculpting. To shape and create you must remove material. I prefer to use electrically powered rotary cutting tools. In the industry, I'm known as a "power carver." I've found it to be a very efficient way of shaping a wood block without having grain direction dictate to me. My tool of choice for this is the Foredom flexible shaft tool model S-R with forward and reverse. This tool has a maximum speed of 18,000 rpm and has been my cornerstone since I began as a professional bird carver 32 years ago.

My first choice in tools for attacking really big works is an electric chainsaw. I have used a variety of electric chainsaws that are capable of removing large volumes of wood very quickly. You must always use extreme care. One momentary slip or a fraction of a second's distraction can easily result in the removal of too much material or much, much worse. Remember: ALWAYS RESPECT YOUR TOOLS!

As you become more experienced and confident you will also become more efficient in tool selection. I love tools and tool catalogues but as I have grown as an artist I've started to do more carving with fewer tools.

Once you've achieved the desired shape, start thinking about the feather groupings and how they relate to not only one another, but also to the bird's overall appearance. Most flying birds are basically put together the same way, but the size and shape of the respective feather groups can vary considerably. Devote yourself to understanding the physical nature and unique characteristics of each bird species you carve. Learn the names of the major flight feather groups and how many feathers make up each group. Know how the feathers relate to one another, not just when the wings are folded, but also when they are partially and fully open. The same thing applies to the tail, which can be very expressive.

Finally, the juxtaposition of head to tail and the axis of the body plane tell a lot about the mood, attitude and direction your bird is heading.

Time to get started!

CARVING THE FALCON

It always starts with an idea. In this case, I am striving to show movement in a static sculpture so I begin with a series of sweeping connecting arcs. Visual rhythm is essential and a positive way to create action. In the early stages, simple lines are best as too much clutter detracts from the direction or focus of the sculpture. (See pattern on page 117.) In addition, as a sculptor, I often create a miniature mock-up of my drawing. I call this my "sketch in three dimensions." This helps me better visualize the overall feel of the piece.

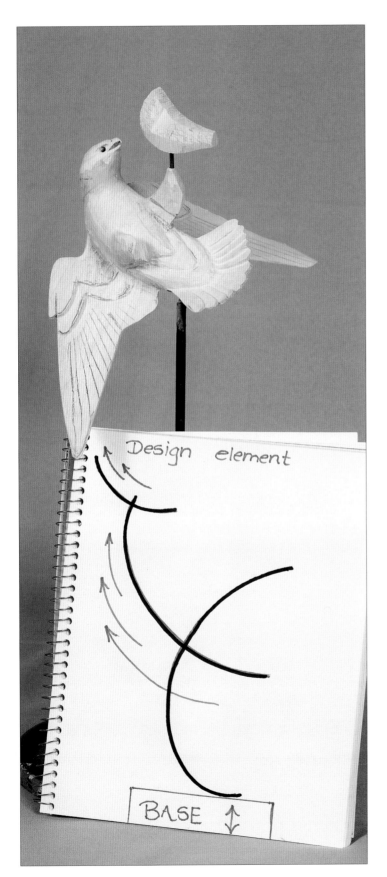

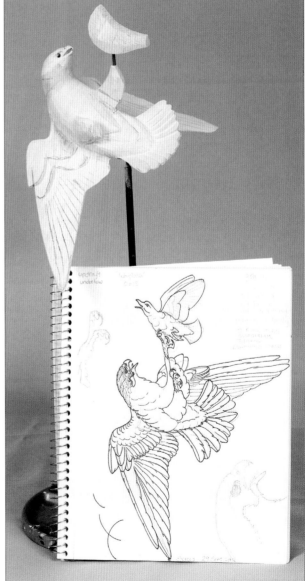

A more detailed sketch follows.

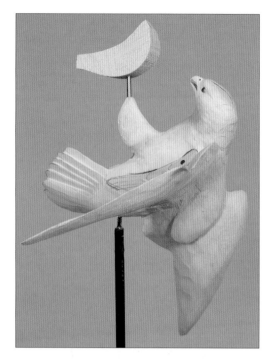

I incorporate just enough detail in the miniature to tell me what needs to be said in terms of spacing and unit relationships between predator and prey.

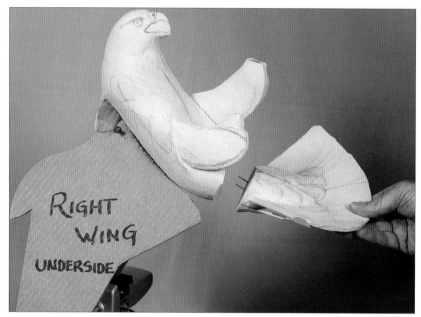

In some rare and complex cases, it may be necessary to create a full-size mock-up as well. I cut off key sections of the body so I can reassemble and try out several different pose ideas. I can stick the parts back on with a couple of small finishing nails due to the softness of tupelo wood. As I try out different ideas I reposition the tail section of my mock-up and reexamine it. It's hard to define, but I just know instinctively when it's correct. Trust your first impression.

I have cut off and repositioned the extended legs as well. This can be a very confusing area. If you don't fully understand what's going on under the feathers—the combination of muscles, leg bones, and attachment points—you won't be able to achieve the right look and balance.

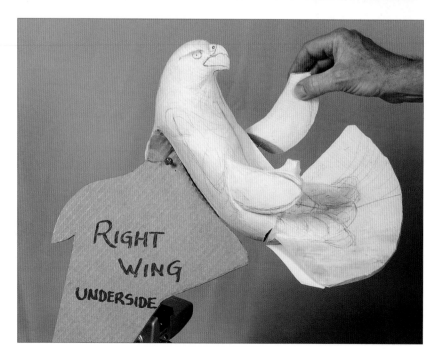

Nothing makes the job go easier than a large, powerful band saw. Pictured is my 20" Delta industrial vertical band saw. I'm using a $1/4$" skip tooth blade designed for cutting free form in thick wood. I like to keep several types of blades available as cutting conditions will always vary due to the thickness of the wood and the tightness of the cuts.

Once I have settled upon a pose and design, I'm ready to begin the actual work on the carving. I have made a pattern out of cardboard by carefully tracing around my full-sized mock-up, leaving a bit extra to allow for subtle modifications as I progress.

I'm careful to leave lots of extra wood around the head and tail areas because I usually make slight changes as I work.

I'm about to begin the first cut. I'm using a Milwaukee electric chainsaw with a 14" blade. This saw has plenty of power and must be controlled very carefully as I begin the task of removing wood from the sides. Proceed slowly and allow the work to evolve.

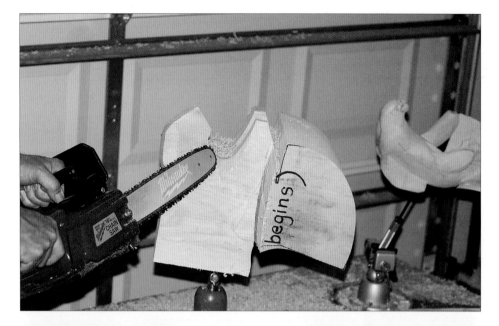

I've firmly attached my cutout to a vise-like holder called a Power-R-Arm. This enables me to solidly position the workpiece in any position I want while keeping both my hands free.

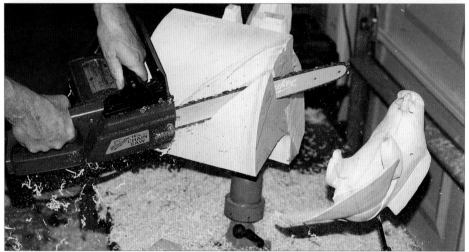

With my little mock-up set up alongside, I slowly and deliberately remove more and more wood. I can't overstate how helpful it is to work with such a useful visual guide. As I work I remain constantly aware of the electric cord location. At this point I must really focus and concentrate on the form that I'm trying to set free.

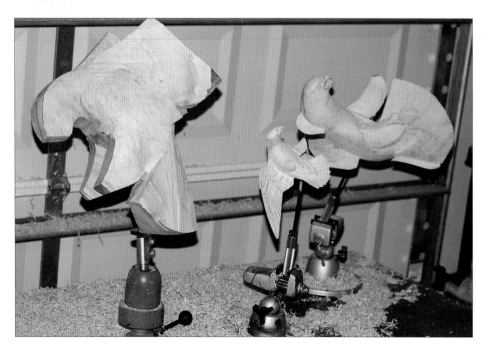

We can call this picture a group of tumbling falcons! This is what my worktable looked like after the first full day of carving. Proper holding devices like the ones pictured here are invaluable. The Power-R-Arm holds the actual falcon and the other two are called PanaVises.

The long (16") blade of the electric chainsaw, kept steady, does a great job of carving broad sweeping areas such as the top of the spread tail.

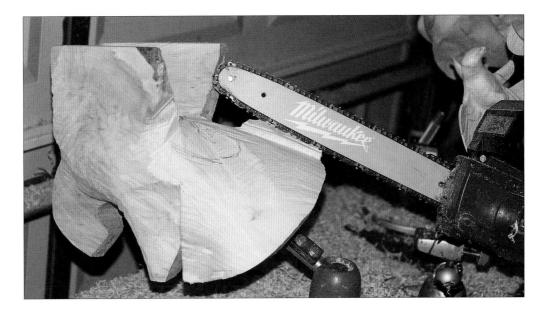

I also use the chainsaw to reduce the width of the outer portion of the legs, or tarsus, areas.

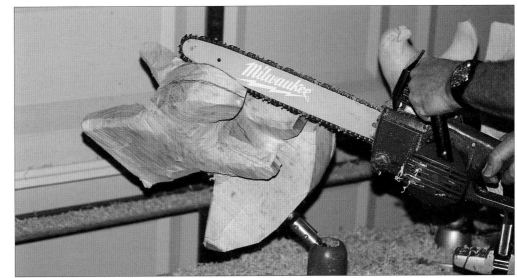

For reasons of strength and continuity I am going to carve the lower wing sections as part of the overall body. This eliminates a lot of trial and error when you are trying to fit the entire wing to the body.

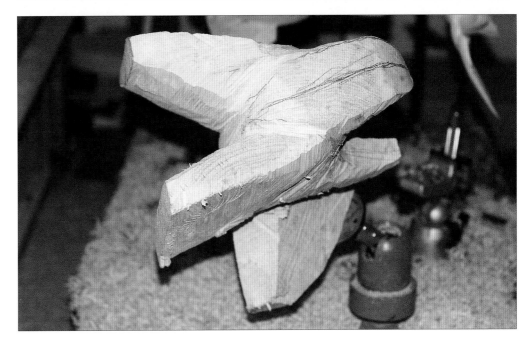

Here I'm placing one of the paper patterns against an area I'm working on to check it for size and shape. Proceed slowly and take frequent breaks. One false slip can set you back hours or even destroy the piece entirely.

The tail area is another place that requires special attention. I want to make sure I have enough wood for all of those beautiful feathers that are still to come.

At long last the time has come to put aside the chainsaw and begin working at the workbench in my studio. These five cutters constitute the business end of my Foredom tool. During the past 10 years I have been using these types of cutters more and more. They make the process of wood removal much easier and give me freedom to sculpt and shape wood regardless of grain direction or variations in wood density. A word of caution to the casual carver: Hold on tight! These are very aggressive and don't differentiate between wood, fabric, and human flesh!

Pictured from left to right:

$3/4$" diameter red Typhoon cylinder (medium cut)
$3/4$" diameter yellow ball Typhoon (coarse cut)
$1/2$" diameter red Typhoon cylinder (medium cut)
Rear: 1" diameter, 2" long sanding sleeve (coarse grit)
Front: 2" long, $1/4$" diameter Typhoon taper (coarse grit)

I will begin the refining process using a medium-grit Typhoon cutter mounted in a 44T Foredom hand piece. I refine and shape the armpit area, the side of the body, and the underwing areas.

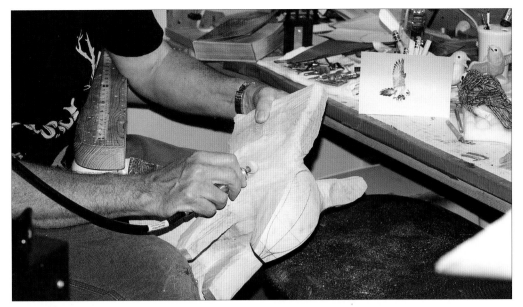

A large round Kutzall works really well to shape the inward curves on the front part of the side of the head. For optimum smoothness I am running the Foredom at full speed, or about 15,000 rpm.

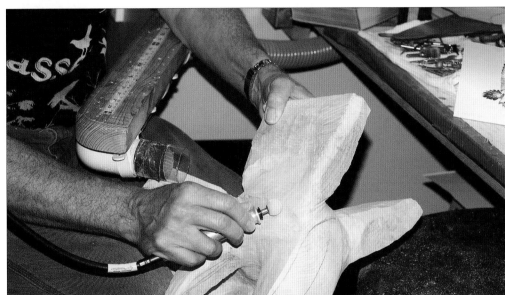

Frequent cross-checks against the smaller mock-up are necessary to keep things on the right track. Looking good so far!

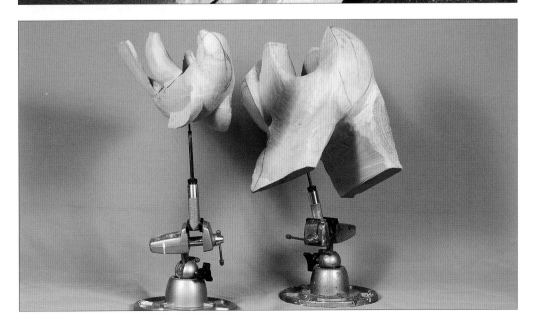

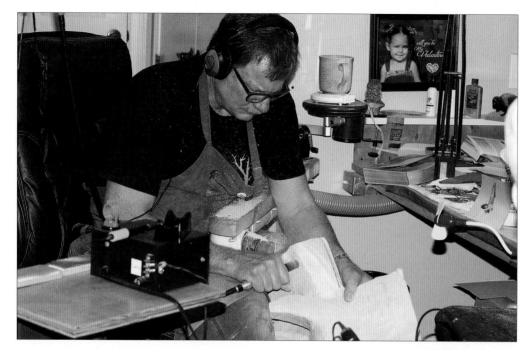

As I'm working on the carving I wear stereo head-phones and listen to music or the radio, sometimes for long periods. These headphones are the Bose "quiet comfort" noise-cancelling variety and are fantastic for filtering out the sound of the Foredom tool and dust collector. Highly recommended!

The Importance of Music

Music is a source of inspiration and motivation for me. It helps get me into the right frame of mind to get on with the task at hand. For instance, I love to turn up the volume and listen to some "high-octane" bluegrass music or electric blues during the rough-out phase. In the bluegrass and acoustic realm, a few of my favorite bands are the Krüger Brothers, Mark Johnson, Mike Dowling, Tony Trischka, Asleep at the Wheel, and the Lonesome River Band. Anything by the Beatles, Buddy Guy, or Stevie Ray Vaughn will definitely get my juices flowing as well.

I settle in for the long task of removing a big volume of wood from the tail's underside. To do this effectively and safely, I must take my time and just grind, grind, grind. Here I'm using a 3/4" Typhoon cylinder. As I work, I direct the sawdust toward the intake of the dust collector. Wood dust can present a serious health threat. I take all precautions whenever I sand or grind by wearing a proper dust mask and utilizing any vacuum systems I have. It's not only the wood dust that can mess you up. The abrasive that wears off sand-paper is also bad for your health if inhaled. Be careful!

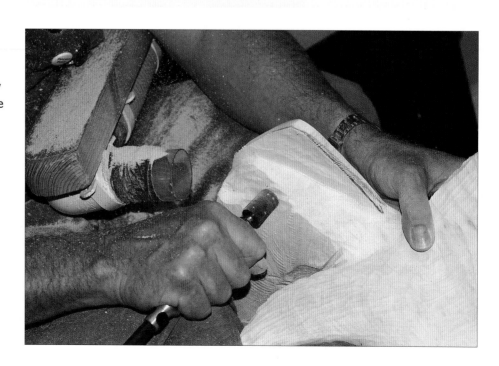

Slowly but surely I'm beginning to see the body take shape. Here I pencil in the shape of the upper-tail coverts and tail feathers.

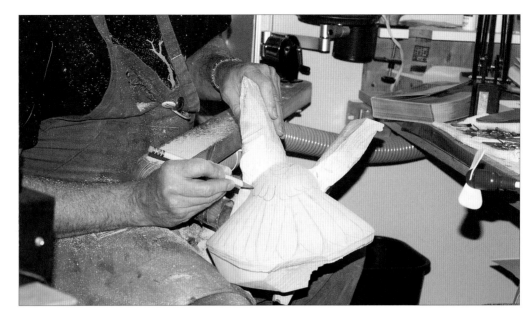

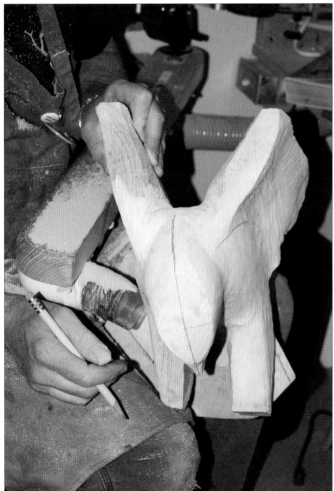

As I slowly shape and refine the back of the head and nape region, I take great pains to maintain a centerline. It is especially important in this highly visible area.

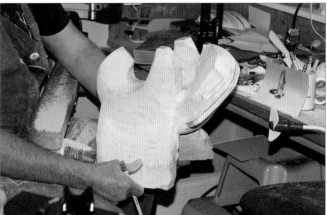

I keep checking proportions as I proceed. Little by little the overall body begins to take shape.

Here's a good look at the frontal area. This region poses certain challenges as it can be a bit of a "traffic jam" of intersecting feather groups and extended legs.

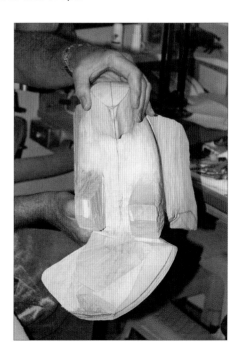

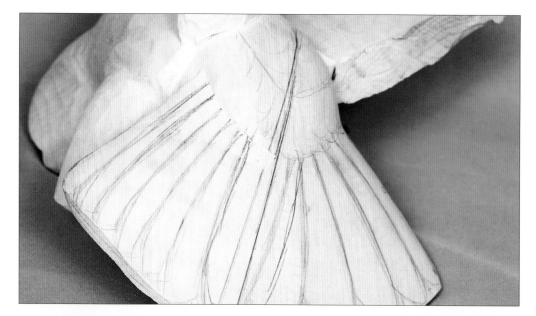

Even at this early stage in development I'm thinking about feather placement. I often sketch in the feathers just to get a sense of directional flow.

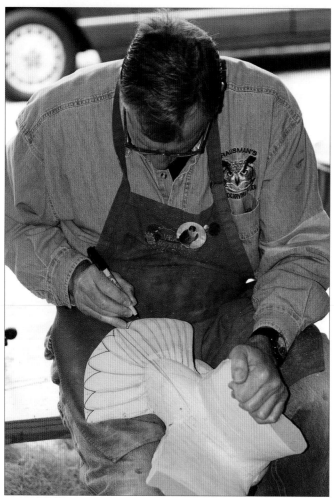

I'm still fussing with the tail. The tail section can be one of the most expressive areas of the whole bird so I give careful and meticulous thought to its overall shape, position, and feather layout. Play this area up to your best advantage and remember that the tail steers the body in flight.

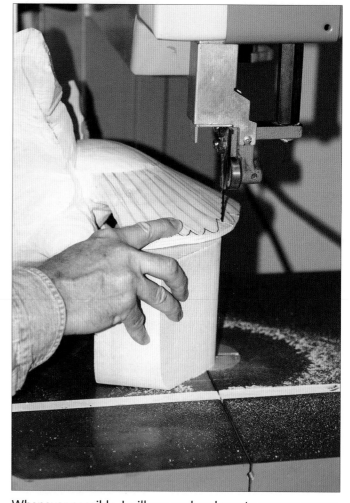

Whenever possible, I will use my band saw to remove excess wood from easily accessible areas. In this case, it's the notches between the tips of the opened tail feathers. As the sections you wish to cut become thinner, use a support block to provide protection against grabbing or binding as the saw cuts through the wood. Safety is paramount.

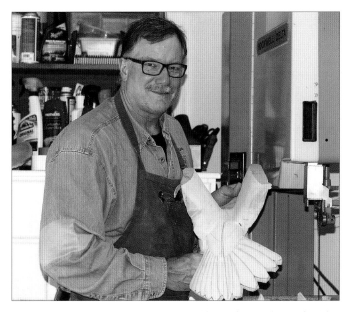

I've successfully shaped the end of the tail. I'm pleased with the result and relieved when the result is a clean, accurate series of cuts.

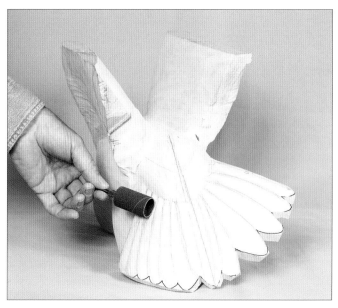

This is the tool combination I use for feathering large areas such as the opened tail feathers. It's a 1" x 1" sanding drum set into a 1" x 2" sanding sleeve. It works well with the Foredom tool.

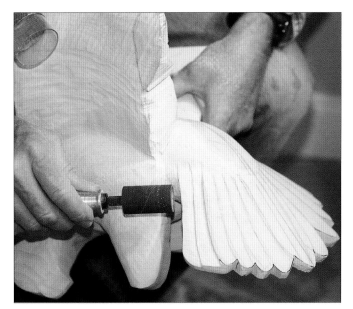

I just couldn't resist jumping into the beautiful tail feathers. Sometimes just putting in a few feathers at an early stage can be a real morale boost.

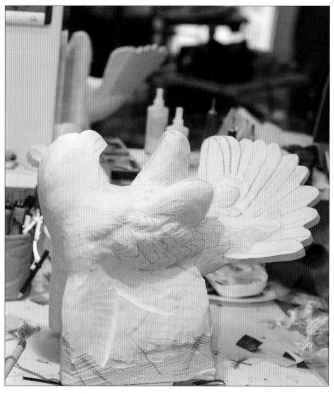

I'm starting to lay out and carve in some contouring throughout the side areas. It's really starting to take shape at this point. The effect of wind on the body feathers of a flying bird can really alter their shape and flow. I've studied countless hours of slow-motion footage of birds in flight and one thing I've noticed is how compressed this group can be.

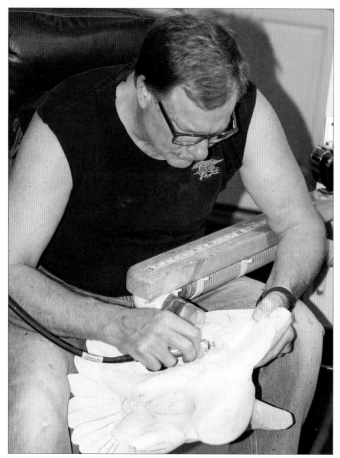

Using a 1" round Kutzall and my Foredom tool I remove vast quantities of material from inside the wing area.

Slowly and deliberately, I shave off more and more excess wood from the underside of the right wing.

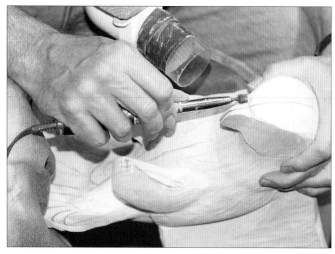

Having accomplished a great deal of carving throughout the rest of the body, I now turn my attention to the head. It can be a nice change of pace to focus on just a small piece of the anatomy after devoting so much time to the overall roughing in of the body and tail. It keeps things fresh to switch to what I call a "transformation area," where just a couple well-placed cuts change the whole look of the bird, suddenly giving it the feel of a falcon.

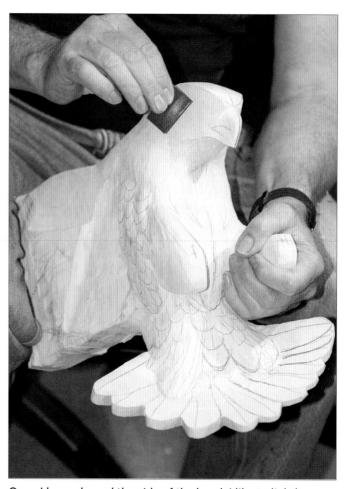

Once I have shaped the side of the head, I like to lightly sand the area in preparation for more detailed and accurate drawing.

For comparison I hold close another peregrine falcon that I've been working on. Often this type of cross-checking helps to keep you going on the right path.

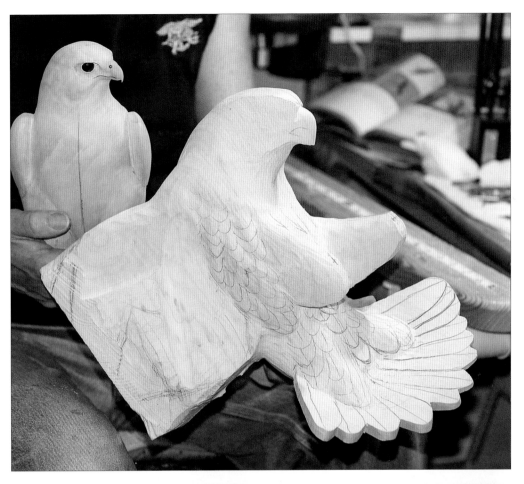

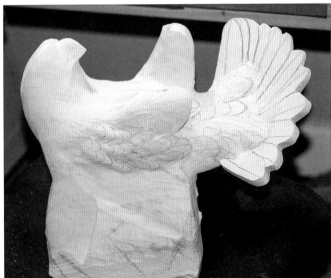

Things are looking pretty good at this point and I'm feeling confident that I'm well on my way to a good piece. I'm very happy with the proportions so far.

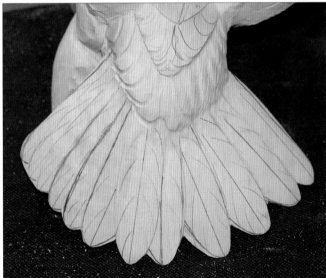

Starting at the tail, I am beginning to isolate and carve in the feather groupings that make up the upper-tail coverts. Draw in the collective feather groupings as well as individual feathers with a soft pencil. Then use a $1/4$" medium-grit ruby ball run at high speed to outline each mark and stone away the excess wood to create a fish-scale type surface.

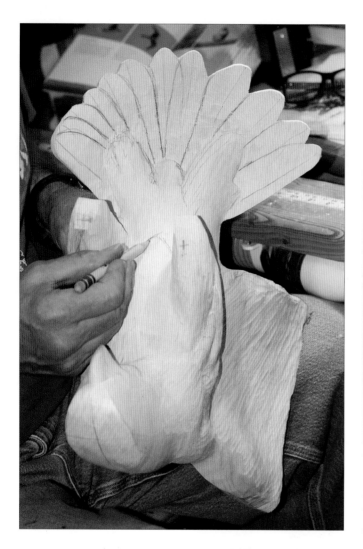

The under-tail coverts are deeper and denser than the uppers and require more pressure on the tool when carving in the feathers. I will aggressively remove more wood in this area so I will often use a small ¼" Typhoon cutter instead of burning out one of my expensive ruby balls. It also puts much less strain on the Gesswein tool, prolonging the life of the bearings and motor.

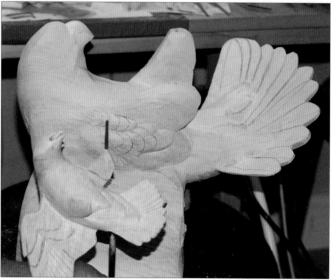

This "midterm" comparison shows the importance of having a smaller physical model to use as a guide. If you don't periodically refer back to your original model and idea, you can easily start to drift off in a different and undesirable direction. I constantly reevaluate my progress.

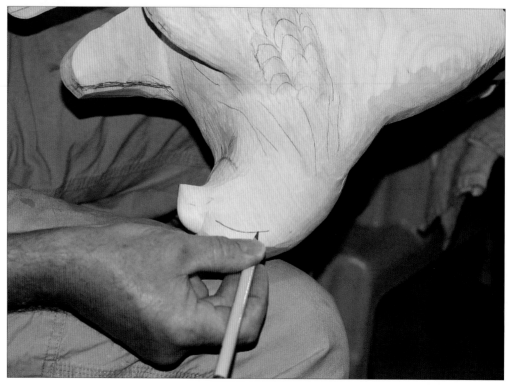

After devoting a sizable amount of time to the tail section, it's time to return to the head. It is very helpful to hop around a bit to change the focus and break the monotony. I begin by drawing in the eyebrow line on each side of the head, making sure they are equal in size.

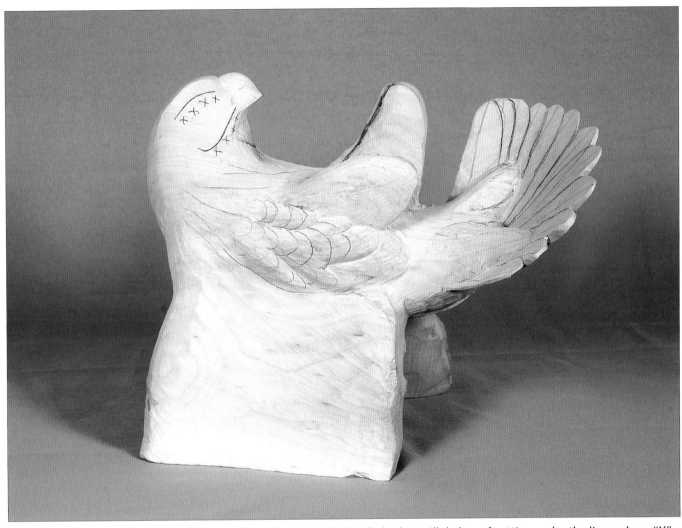

The wing stubs make a super stable stand for setting down the bird's body. I will do lots of cutting under the lines where "X" marks the spot.

I'm using a $^3/_8$" diameter round Typhoon cutter, mounted in my Gesswein tool with a Slender Head attachment and running at about 33,000 rpm.

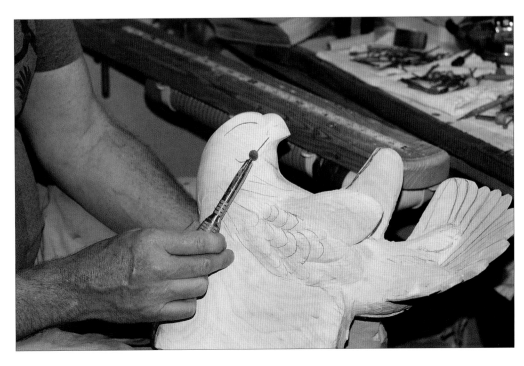

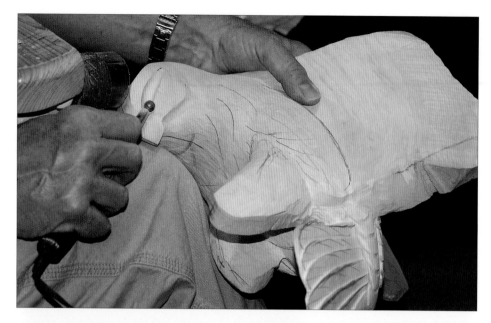

The jaw and brow cuts are good examples of "transforming" cuts because they drastically alter the look of the head as it begins to take on a definite raptor quality.

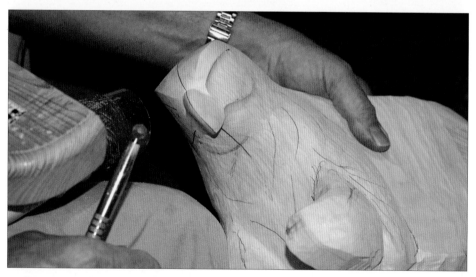

I like to be very aggressive when I make these cuts. For consistency I typically initiate my cut from the front section and work back. I strive to make the cuts smooth and not choppy, as my margin for error is becoming smaller. On the jaw, the deepest cut is closest to the beak. The deepest part of the eye channels is around the area where the eyes will go.

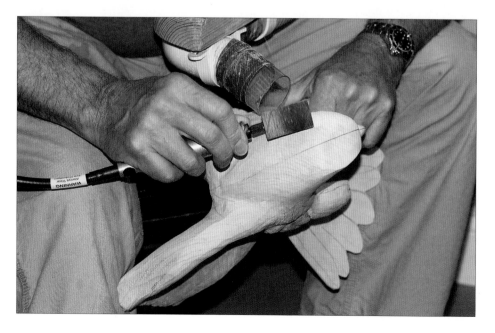

The Foredom tool with a 1" x 1" medium-grit sanding sleeve works great for smoothly rounding over the edges of the head block.

Here's a nice profile view of the overall carving. At this point in the process I can begin to see the flex in the body, which gives the impression of strain as the falcon fights gravity and grabs out to lock onto its quarry.

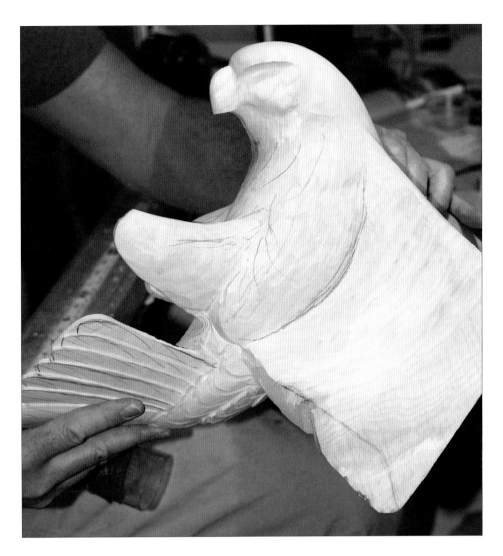

It's always helpful to enlist the expert advice of a trusted colleague. Here, I'm visited by Peter Spadone, a master falconer, musician, and friend who happened to be in the neighborhood. I had been struggling with the placement and relationship of the under-tail coverts when the tail is spread as in flight and Peter had the answers.

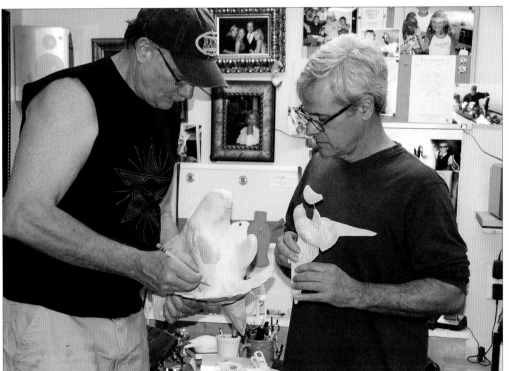

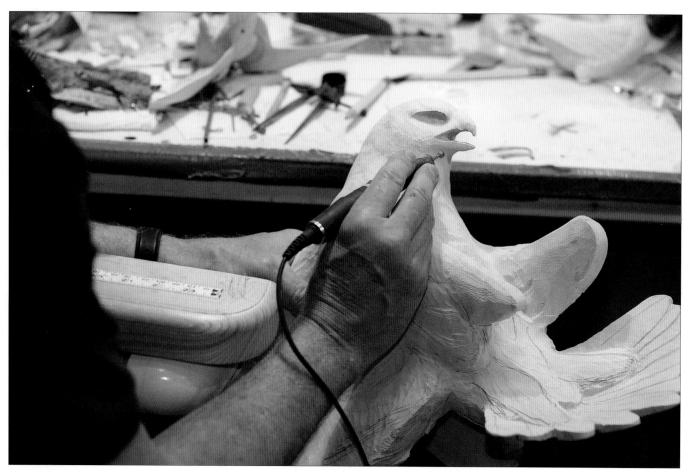

The performance capabilities of the new Gesswein high-speed hand piece give me tremendous control while carving delicate areas around the jaw and beak. As the areas to be shaped become smaller and more delicate, you need to use smaller, less aggressive tools. I have a whole collection of fine-grit diamond cutters that cut very efficiently and are great for critical areas such as the upper and lower mandibles and the sharp hooked tip of the beak. Once I've carved and sanded the beak I apply a few drops of ultra-thin super glue and allow it to soak into the wood. This strengthens it tremendously and helps protect against breaking.

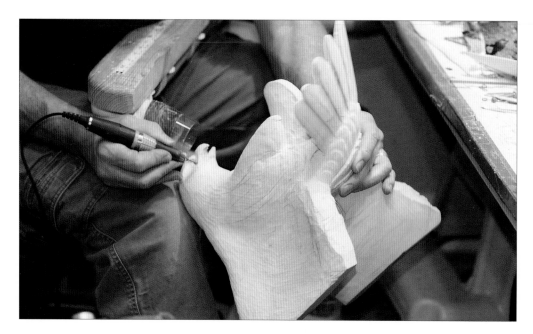

By deepening the eye channels with a medium-grit $1/4$" ruby ball I give the falcon a fiercer look. I can intensify the "look" of my raptors in subtle ways, such as deepening the eye channels a bit more than the real ones are. Setting the eyes a little deeper helps make the bird look mean!

I've completely carved and feathered the rump. This area is feathered much the same way as the rest of the contour areas. I did carve in the feathers so they look a little more stretched out than normal, giving the bird a dynamic feel.

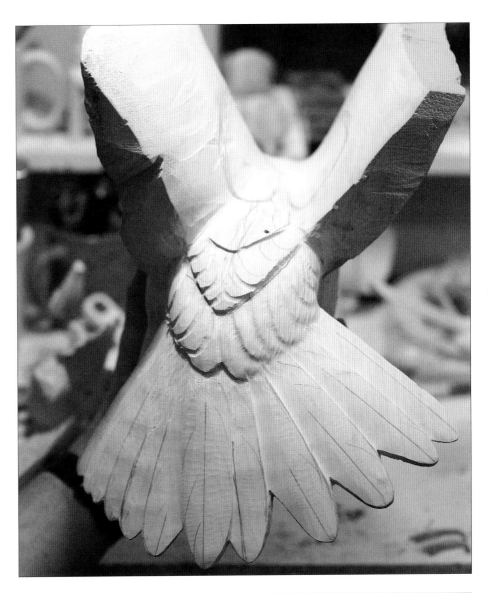

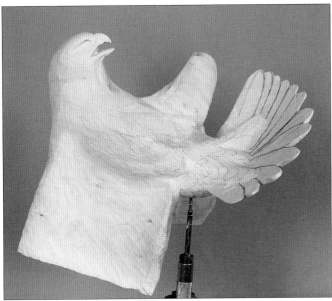

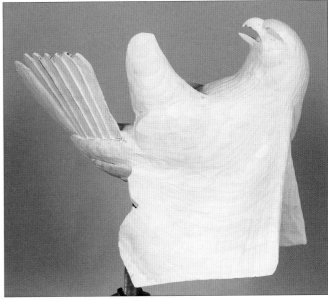

The falcon is emerging in a great way. The sweeping flow of the opened tail gives the bird a real look of motion throughout the body.

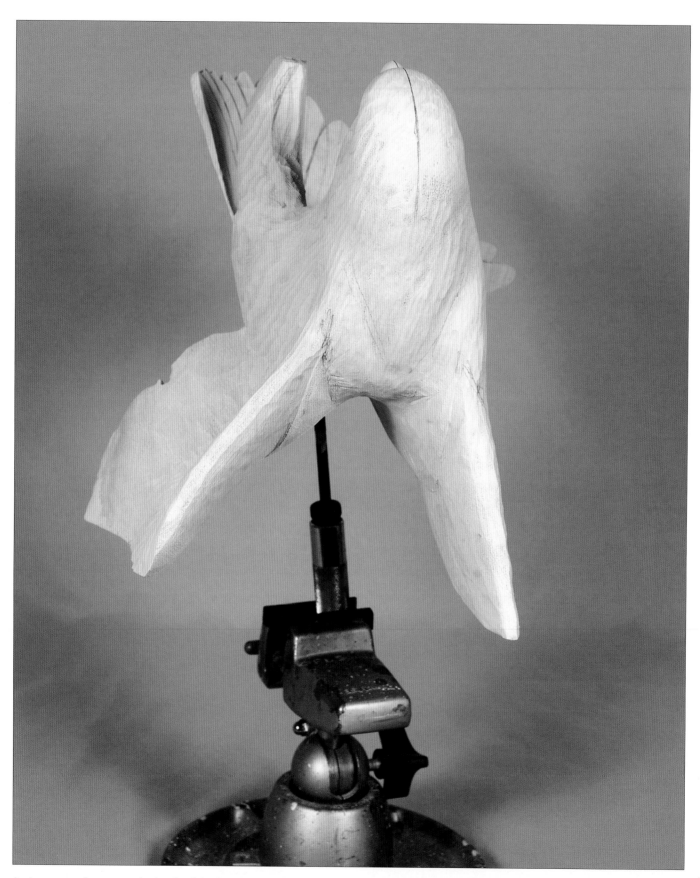

As I carve and contour the back of the head and into the nape region, I strive to give the visual feeling of stretching within the feather groups. I accomplish this by elongating the feathers within each group. I may slightly exaggerate the spacing of the feathers to show dynamics and motion within a feather group.

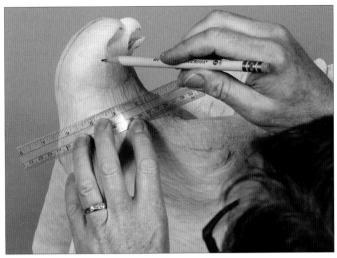

Accuracy requires careful layout and measuring. A clear flexible ruler makes this task much easier on round surfaces.

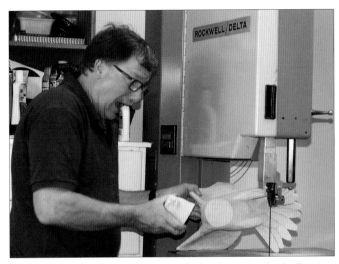

In an effort to allow access into the body cavity for hollowing out, I must resort to a rather drastic step: I cut off the head!

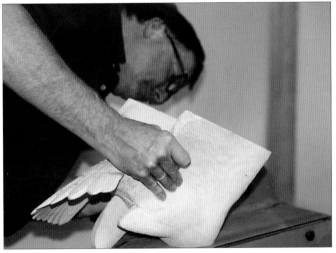

After making the initial cut with the band saw, I use a 6" x 48" sander to smooth the cut area and make sure I will have a nice, tight match between the head and body when the time comes to reattach them. Here I'm sanding the body side.

And now the neck.

I plan on leaving a wall thickness of about $3/8$ of an inch throughout the body. This is a big bird in flight so weight is critical. I will even hollow out the head as much as possible.

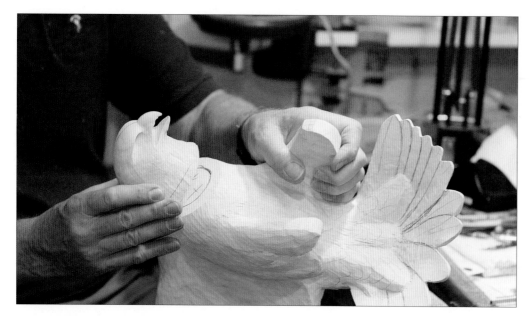

I do a test fit to make sure the wall thicknesses are compatible.

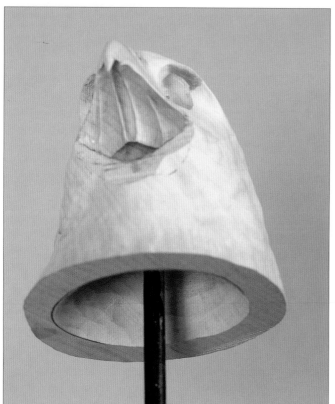

I made the falcon's tongue from A+B Epoxy putty (available from Jaymes Company). After mixing the epoxy, let it sit for about 45 minutes until it begins to firm up. Roll it out into a worm-like shape and flatten it. Then take a small smooth pointed tool like an awl and form the center crease lengthwise. Sometimes it helps to moisten your fingers to prevent the epoxy from sticking to them.

I've done more detail on the detached head and hollowed out the inside of the head cavity. To hollow I used a $1/2$" Typhoon ball cutter mounted in a Foredom hand piece. I cut off the lower mandible with an extremely fine jeweler's handsaw to allow access into the throat and mouth areas. Using a $3/8$" fine-grit Typhoon ball with $1/8$" shaft mounted on a Gesswein Slender Head to extend my reach, I slowly cut in the throat tunnel. I carved the soft palate areas of the upper mandible with a $1/8$" fine-grit ruby ball run at high speed in my Gesswein Z-55X hand piece.

Pictured are the detached lower mandible and the completed tongue.

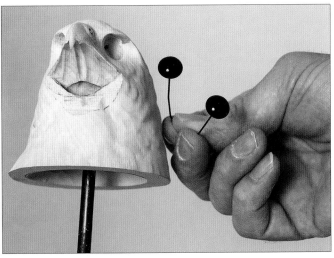

Often when I begin focusing on an area I tend to stay focused and "go with the flow." In this case, I was in a good position to set the eyes and reattach the lower mandible. For a raptor, few things are more important than the eyes! My number one supplier over the past 30 years has been Tohickon Glass Eyes in Erwinna, Pennsylvania. These eyes are style #115 blended glass eye on wire, custom made for me by master craftsman Tony Alfaro.

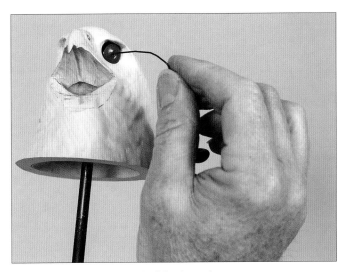

I test fit the eyes to see if all looks right.

While the lower mandible is removed, I take advantage of the access it gives me to paint the inside of the mouth. Here I've applied the gesso as a painting base.

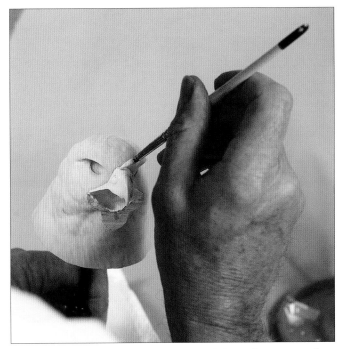

Why not paint the beak while I'm at it? Once I've gessoed the upper mandible area and beak/cere, it's ready for final painting.

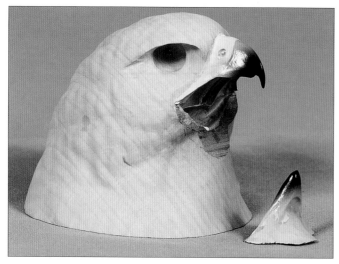

I airbrush on the beak's base color, a mixture of 70% white and 30% Payne's gray that produces a soft-looking powder blue. Once dry, I spray just the tip of the beak with a mixture of 90% Payne's gray and 10% raw umber and give it several coats.

I've mixed up some A+B Epoxy putty to set the eyes. Pay attention to your proportions and be sure to make a 50/50 mix.

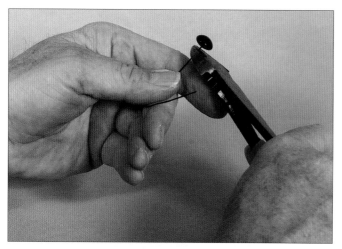

I cut the wire, leaving about 1/8 of an inch on the eye for alignment purposes.

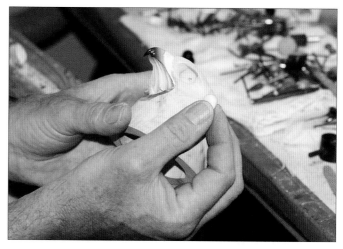

I've taken the well-mixed putty and rolled it into a ball. It's now ready to be pushed into the eye socket.

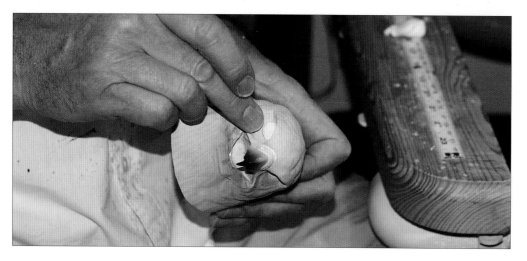

With a wet finger, I push the putty into the eye socket.

To make sure each eye is set at the same depth it helps to put in equal amounts of putty and do a visual inspection. Hold the head up to a mirror and look at the reflected image. This will show if something is out of whack.

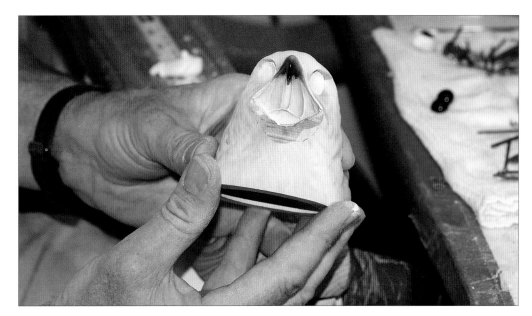

Set the eye into the socket and use a pencil eraser to adjust it by gently pushing on either side.

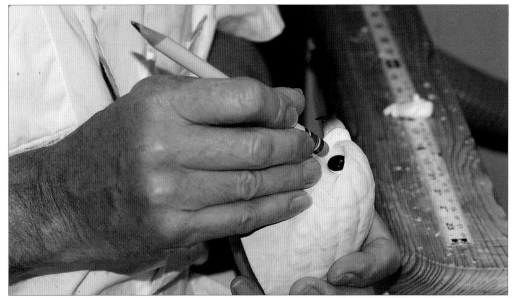

Once both eyes are properly set, use a small flat tool to smooth around the perimeter of each eye.

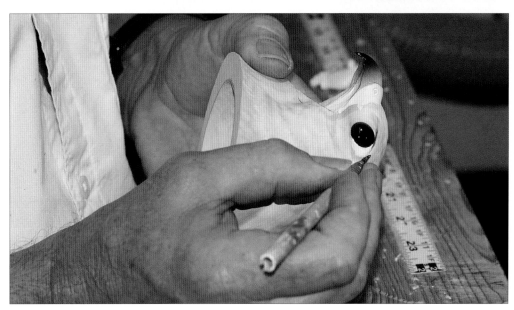

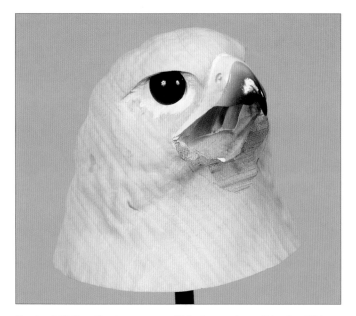

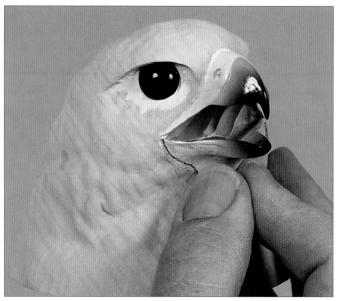

I'm test fitting the lower mandible to see how it looks. This is a point where I get very excited because I can really see things coming together.

The completion of a very important part of the whole operation! PHEW! I mount the head on a holding device and look at it for several days to make certain everything is perfect. So far, so good...

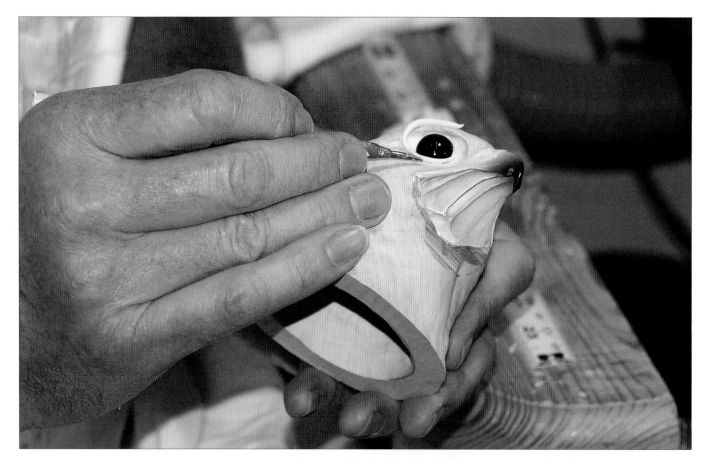

Once I'm sure I'm satisfied with the eyes, I set the lids. To do this, let the mixed epoxy firm up for about 10 minutes and then roll it out into a worm-like shape, tapered at each end. The little worm should measure about an inch long and be $1/8$ of an inch in diameter at its thickest point. To form the eyelid around the eyeball I use a custom-made "eye tool" that I constructed from a piece of $3/16$" copper wire that I bought at a local hardware store.

The eyelids have both been set. The task is made so much easier when the head is separated from the body.

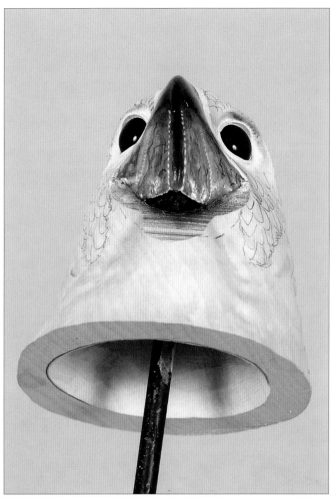

I decided to paint and super detail the inside of the roof of the mouth and get it all finished. I've developed a basic flesh-tone color of 70% white gesso, 15% cadmium red medium, 10% yellow oxide, and 5% ultramarine blue. When that's completely dry, cover everything with a thin wash of burnt sienna and let the pigment settle into all the deep pockets. Let this dry completely before giving it a coat of gloss polyurethane.

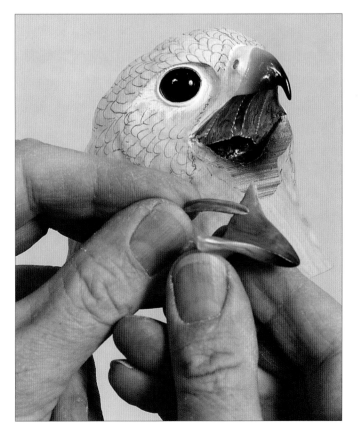

It's time to reattach the lower mandible. First I must check the tongue to make sure everything will fit properly. To glue it all together I use a two-part, five-minute epoxy mixed with a pinch of fine sawdust to thicken it up and prevent it from dripping. This mixture also acts as an effective gap filler. HINT: You can add color to the epoxy mix by stirring in a little bit of acrylic paint. Don't be afraid to experiment.

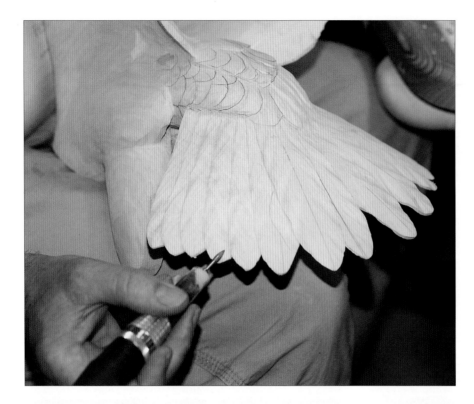

I go back to work on the tail feathers and upper-tail covert grouping. The flight feathers of the tail and wings are some of the most dynamic and complex parts of a bird's anatomy. I love to get creative in these areas by adding ripples and splits and carving in separations between the feathers. Few tools work better for carving these separations than a fine-pointed diamond bit run at high speed in my Gesswein hand piece. Keeping a steady hand, I hold the tool at a low angle as I remove wood, creating a wave effect along the sides of the feathers. At the tail tips, the same cutter very effectively creates more separation.

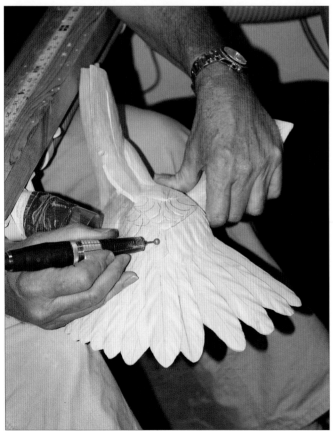

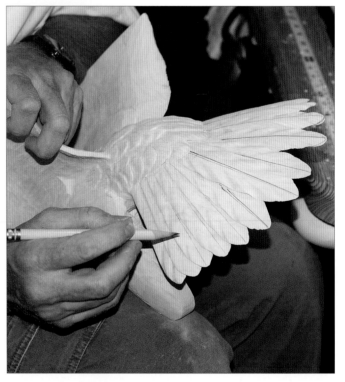

Now I draw in the feather shafts on the top tail feathers. I use a soft lead pencil and a flexible plastic straightedge to make them look correct.

I stone the upper-tail coverts using a 1/4" ruby ball run at top speed (55,000 rpm). My goal is to show contouring and feather groupings and to give the surface a quilted look in preparation for final sanding and, ultimately, wood burning the texture.

Using a wood burning pen with a spade tip I burn in the converging lines that form each shaft. Use a low heat setting when you do this and try to and hold your hand steady. Move your whole arm, not just your wrist, when making the stroke.

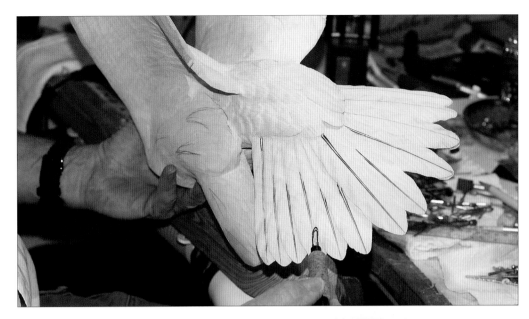

Once I've burned in the lines, I lay the burner down on its side and compress the wood surface on each side of the shaft, leaving the line elevated. This looks just like the fine shaft of a real feather. The wood burner leaves the wood nice and smooth along the shaft.

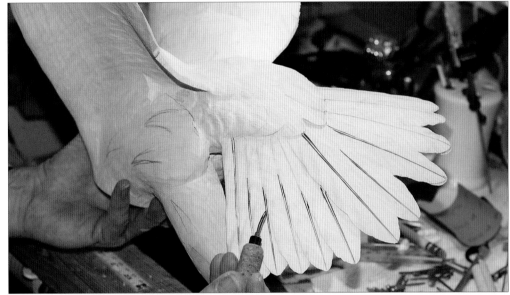

I return to the head. I am beginning the texturing on the top using a spade tip on my Colewood detailer. This is how I will do all the contour burning throughout the falcon's body. I prefer using the spade tip because it allows me to curve the lines with greater ease, which enhances the round-ness of each feather.

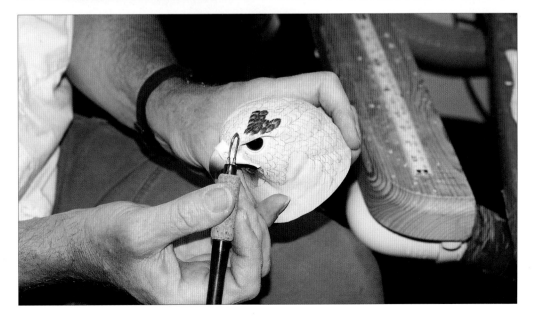

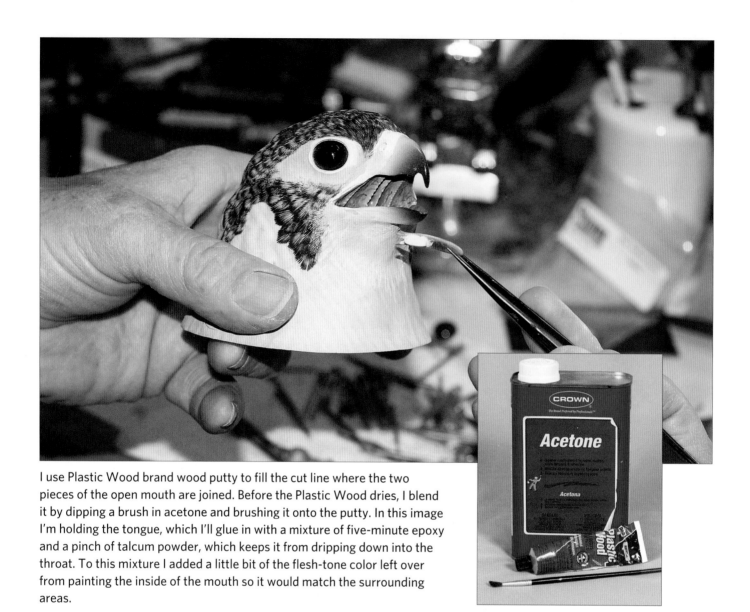

I use Plastic Wood brand wood putty to fill the cut line where the two pieces of the open mouth are joined. Before the Plastic Wood dries, I blend it by dipping a brush in acetone and brushing it onto the putty. In this image I'm holding the tongue, which I'll glue in with a mixture of five-minute epoxy and a pinch of talcum powder, which keeps it from dripping down into the throat. To this mixture I added a little bit of the flesh-tone color left over from painting the inside of the mouth so it would match the surrounding areas.

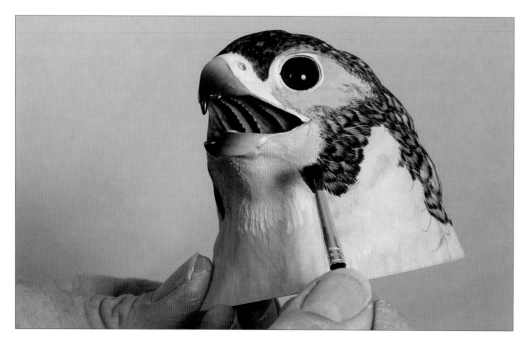

The blended area is almost indistinguishable from the surrounding wood.

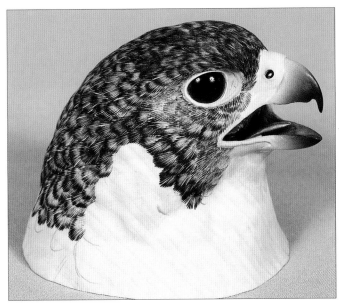

Here's the head with most of the contour burning completed, with the exception of the areas around the eyes. The completed head is ready for reattachment onto the body.

With the head completed, I start to think about the wings. I've made cardboard patterns of the wing tips and traced them onto tupelo wood cut to a thickness of one inch.

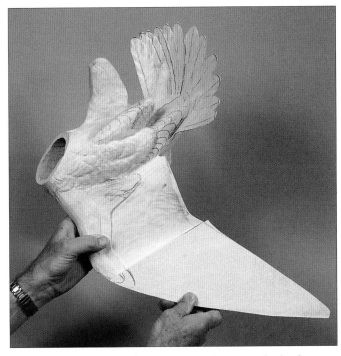

Here I test fit a roughed out wing section onto the body. Perfect fit! I will use a threaded steel rod and epoxy to hold the two parts together once they are permanently attached. I cannot overstate how important the integrity of these two wing joints is! They must be solid and tight.

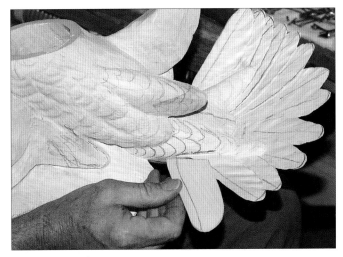

I want to create the feeling of separation that exists between the outer tail feathers and those within the center of the tail mass, so I decided to carve the outside tail feathers separately. I will insert them once they have been sanded smooth and textured.

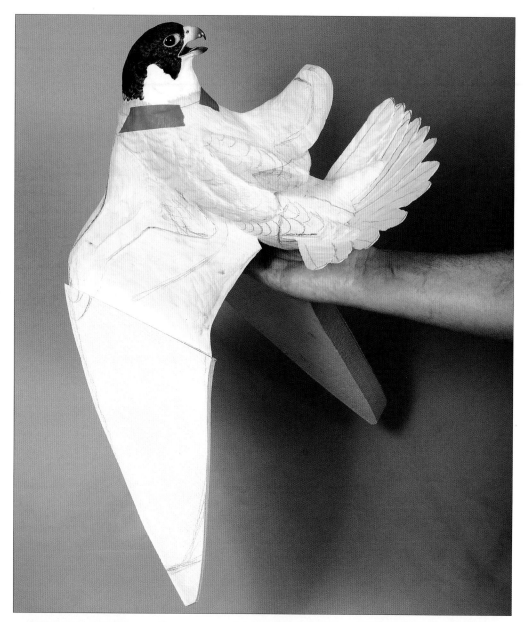

My excitement gets the better of me and I give the detached head a couple of wash coats of color just to make it look more peregrine-like as I hold up the fully assembled falcon for the first time. This is a big day—all the parts are coming together! If memory serves, I opened up a cold beer and then took my wife out for a nice relaxing dinner!

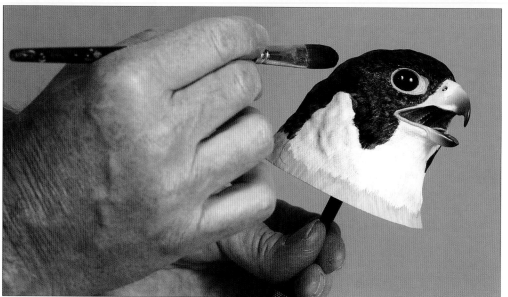

After applying several thin coats of white gesso onto the head, I begin applying many thin wash coats of a mixture of 50/50 ultramarine blue and burnt umber onto all the burned areas until I get a rich black coloring.

For a viewer, no other area of a sculpture calls out for immediate examination and sets the personality and tone of the bird more than the head. This small area can make or break your bird. Eye placement and setting; beak shape, coloration, and patina; and fine feather flow around the eyes and corners of the mouth—all challenge the skills of even the best artisan. You must treat these disparate elements with extra care and attention to detail if you want to be successful.

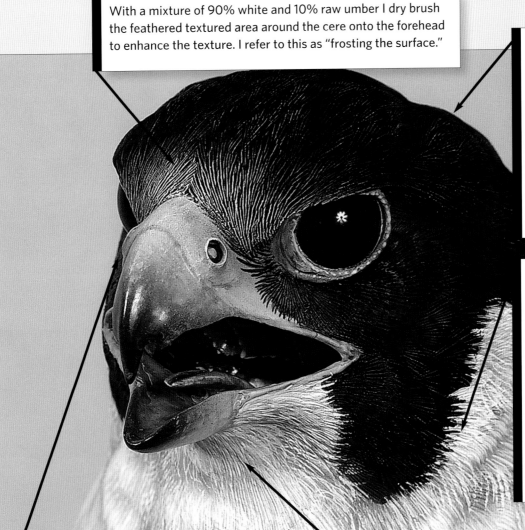

With a mixture of 90% white and 10% raw umber I dry brush the feathered textured area around the cere onto the forehead to enhance the texture. I refer to this as "frosting the surface."

Ultra-thin wash coats of 50% burnt umber and 50% ultramarine blue have been applied over the feathered sections of the head. You need up to 10 layers to achieve the tight "satin" look, which is enhanced by the super tight texturing of the surface.

Use lots of patience when painting white areas. Create depth by airbrushing a mid-tone gray color into the contour valleys. Paint on a mixture of straight white gesso with a drop or two of flow medium, one curved stroke at a time, with a pointed #6 sable brush. The effect I'm trying to get can be best described as soft and fur-like.

Paint the outer surface of the beak first with a mixture of 70% white and 30% Payne's gray as a foundation. Then carefully airbrush the tip and allow the dark color to fade into the soft gray/white, with the darkest area at the very tip. This may require two or three applications, allowing each coat to thoroughly dry prior to the next spray. Paint the yellow cere and eyelids with multiple layers of 70% white and 30% yellow oxide. Once that's totally dry (preferably overnight) I apply several coats of satin polyurethane to the beak only—not the cere or corners of the mouth. I use MINWAX brand polyurethane, available at any quality hardware or building supply store.

I handle the throat much the same as all the other white areas; however, to shadow it a bit, I will wash over the area with a VERY thin wash of ultramarine blue.

The head is now totally painted. (For more about my painting philosophy, see page 65).

I'm wood burning texture onto the outside tail feather prior to attachment. For 90% of the overall burning, I will use the spade-shaped tip. I like the control it affords me and I'm just comfortable using it. I set the wood burner to a medium heat setting.

The image below clearly shows the collective grouping of all 12 tail feathers. The surface preparation of the tail feathers is critically important if you want to burn them tightly and with consistency. I have already textured one of the outside feathers and am off to a good start. All the feather shafts have been carved in as well. Just 11 more to go. It is helpful when burning a large smooth area like the outside tail feathers to draw some pencil lines as a visual guide prior to burning.

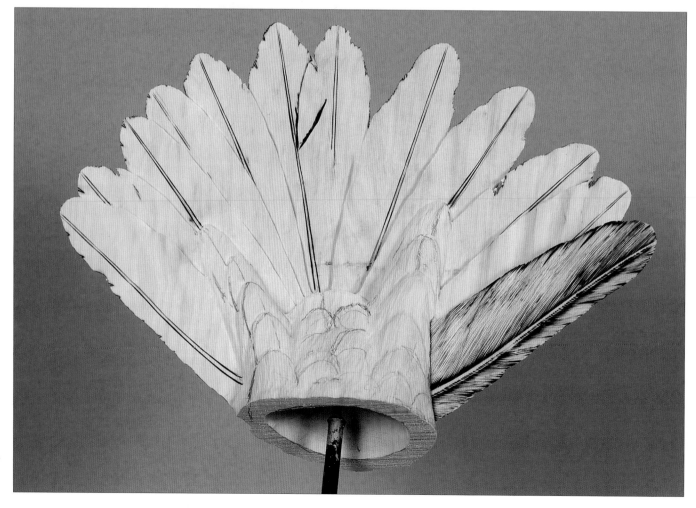

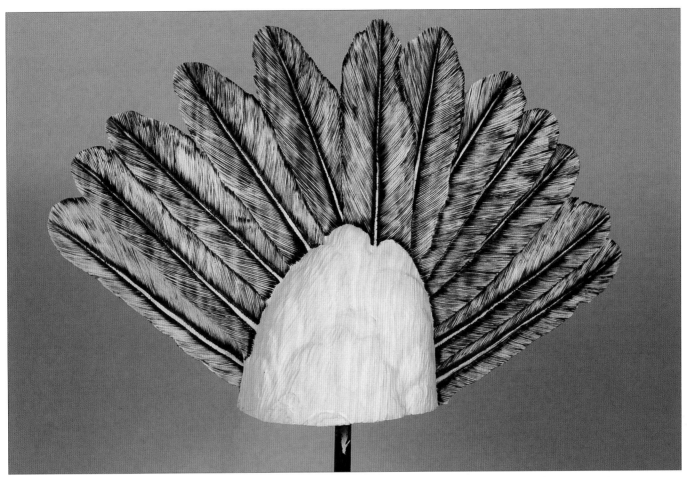

This is the objective you are after while burning. All 12 tops have been completely burned and now the upper-tail coverts await additional work. I like to work in sequence when texturing the body. Starting at the tail, I burn the lowest feathers first and progress upward towards the front of the bird.

As I did with the head, I cut off the tail section to allow access to the rear areas of the hollowed out body. For the majority of hollowing I used a 1 1/2" wood-boring bit mounted in a powerful electric drill. I continued to drill and chop out all the unneeded wood I could, then went in with a 1" round carbide cutter mounted in my Foredom tool. This took a bit of time and care as I sure didn't want to bust through the wall.

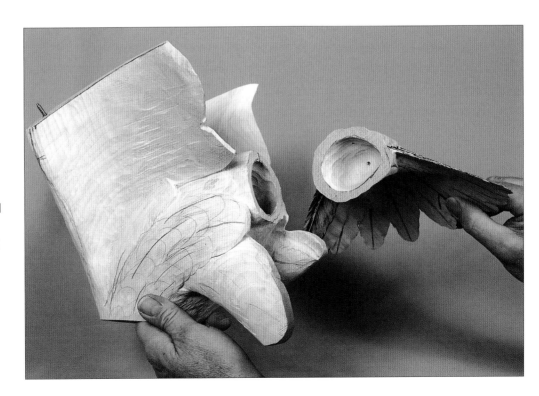

I keep a close eye on the hollowing of the body cavity. The overall success of the balancing act I was trying to achieve with this sculpture was directly dependent on overall weight reduction, since the entire two-bird composition will balance on a single $3/16$" steel rod. Hollowing out the body achieves two things. It reduces weight and eliminates any internal stresses that might occur at a later date.

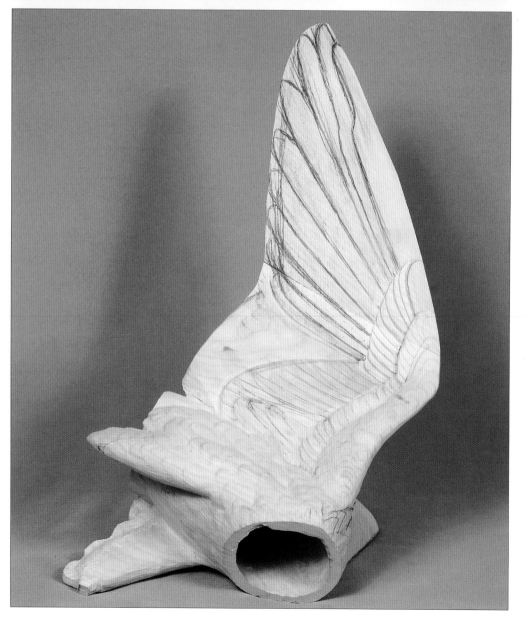

The underside of the falcon's right wing is all laid out. I'm ready to carve in the individual feathers.

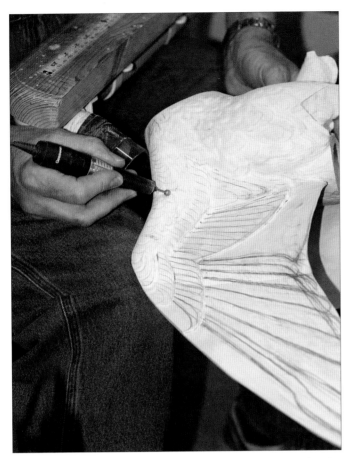

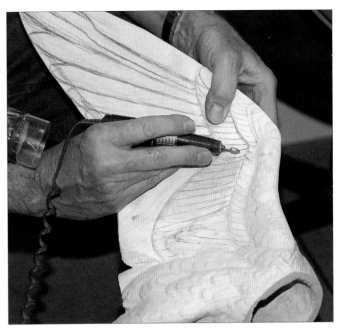

The complexity and incredible variation of the underside of the wing feathers requires a variety of carving tools. The best combination I've found is the ¼" round Typhoon cutter mounted in my Gesswein Z-55X hand piece. I've found that it's much more difficult to carve and feather a concave area like a wing underside than a convex area like the top of a wing. Others may differ in their opinion but that's just me... At this point I have temporarily attached the outer wing sections to the body.

I use a ruby flame-shaped cutter to carve in the major flight feathers. I can use the tip to achieve definition along the sharp, clean edges of the individual flight feathers. In addition, the broad arc of the side of these cutters adds an accurate concave shape to the overall body of the underside of the feather. I will certainly mix and match with different cutter shapes as I go about the carving of the disparate feathers found within each group.

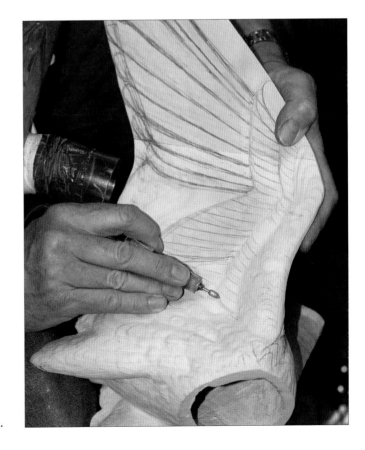

Many hours of tedious carving are behind me as I work to complete this busy section of the falcon's underwing anatomy. I say "busy" because of the many distinct shapes, sizes, and textures of the feathers that make up the overall underwing surface. Soft, almost fur-like feathers of the upper armpit area contrast with the knife-like stiff flight feathers, making for a challenging area to represent in wood.

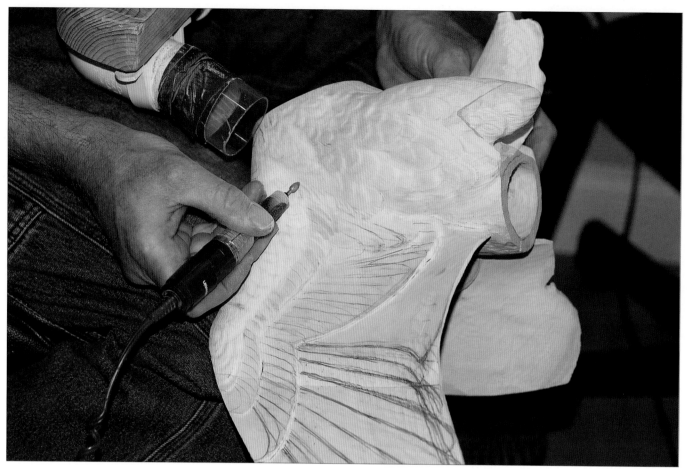

When I carve the junction between wing and body I want to convey high animation. These are highly important areas that require special attention and creative layout. To do this with some degree of success, try to shift the spacing of the individual feathers found within each grouping as well as the depth to which you carve each one. Try to show motion by imagining a hand-held fan being opened quickly. These are the specific DYNAMIC areas that will set your work apart from all the others.

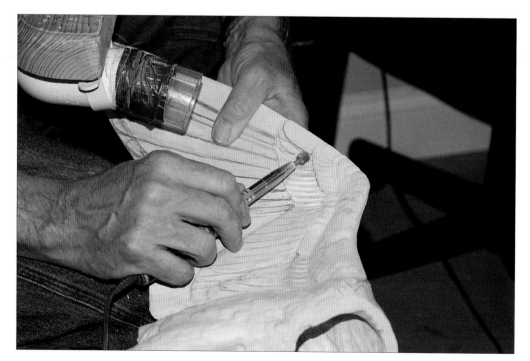

Using a small stump cutter I carve in the upper primary covert feathers of the falcon's right wing. The stump cutter removes large volumes of wood with greater ease, especially on a convex area. It can be a real timesaver.

Test fitting all the component parts. The clothespins work nicely to temporarily lock together parts in preparation for permanent attachment. The red line locates the position of the steel support rod.

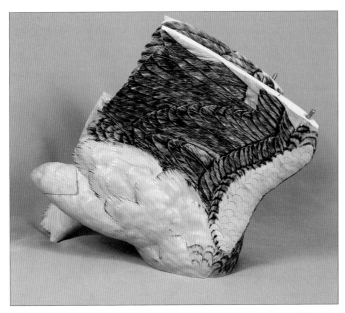

Slowly but surely I burn in all the underwing feathers. The rounded edge of the spade tip burner works well for this type of burning. I have removed the wing tips for this step—you can see the attaching screws.

I find it's easier and less intimidating to do the texturing, sealing, and even painting of one section at a time. When doing a large, time-consuming carving, the project feels more manageable when you break it down this way. Here I've textured, sealed, and even applied gesso to the underside of the left wing.

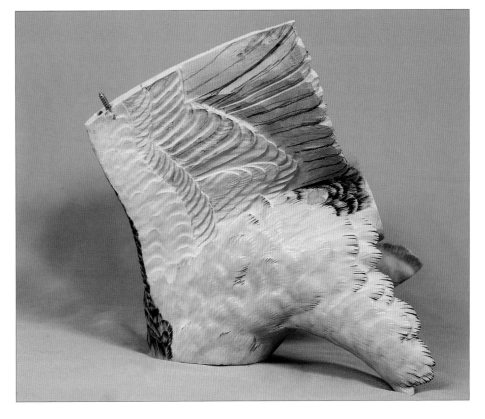

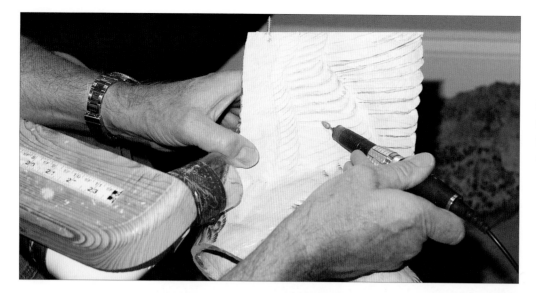

Utilizing a variety of cutter bits and sanding drums, I carve in the individual flight feathers on the underside of the falcon's right wing.

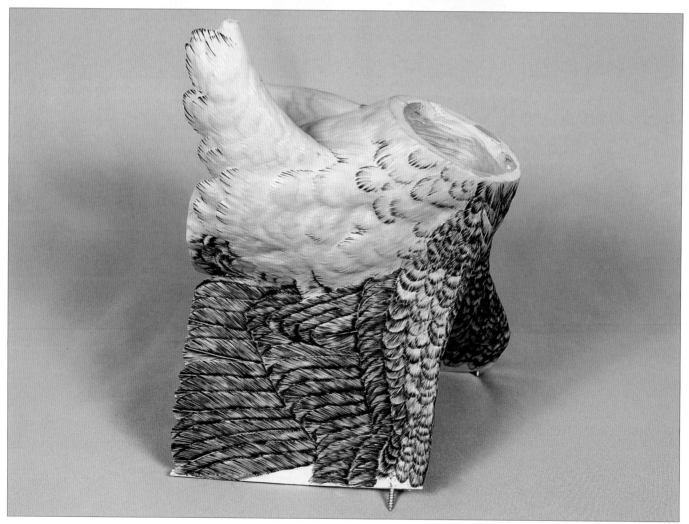

It's been said that a picture is worth a thousand words. This image of the midsection clearly illustrates how various types of surface texturing create certain effects. I used a spade tip burner with the heat set a little bit hotter to burn in the flight feather texturing on the wings. The same tip with a lower heat setting accentuates the edges of the soft, flowing feathers on the sides of the body, which have already been lightly stoned for texture. Don't be afraid to mix and match your texturing. It is certainly not an either/or issue when it comes to doing what's best to create an effect. On the overall contour areas I'm always trying to play up the roundness and soft look of the surface.

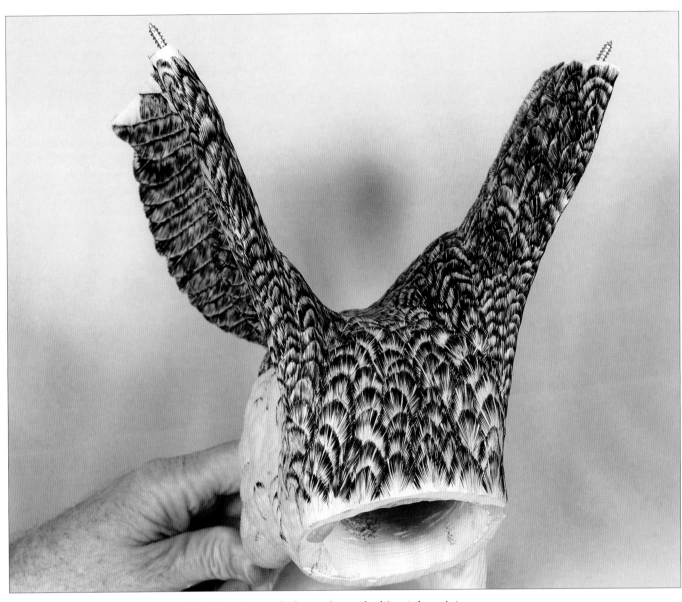

A top/front view of the completed midsection ready for sealer and, ultimately, paint.

The underside primaries top and bottom have been totally textured with a burning pen. At this stage, it's ready for attachment to the body.

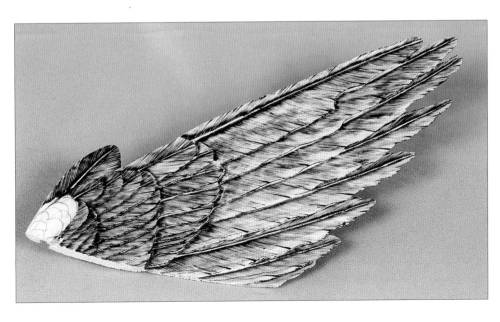

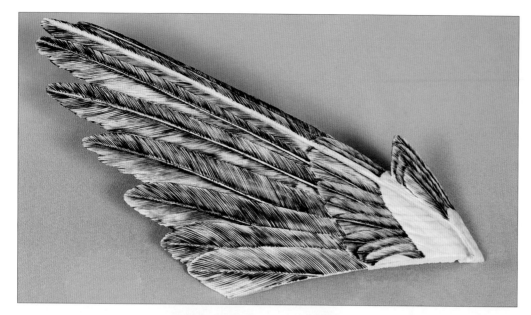

The left wing flight feathers are totally textured. You can see the slot in the wing where the steel rod supporting the falcon will go. I carved it with a cylinder-shaped stump cutter held vertically like a hand-held router bit. I then followed up with a $3/16$" ruby ball, which matches the diameter of the steel rod I'll be using for the support.

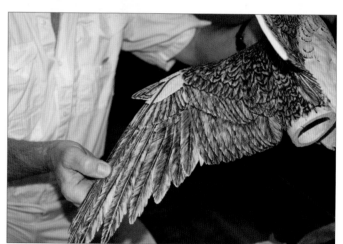

I'm ready to put it all together.

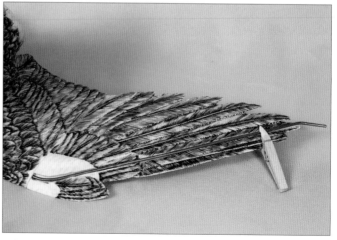

With the wings permanently assembled, I test fit the steel rod prior to permanently gluing it in. I was very specific about the qualities I needed in the support rod. It had to be incredibly strong yet flexible enough so it would bend and not snap if stressed. I settled on a $3/16$" diameter stainless steel rod known in the industry as #304 stainless. It's not something you'll normally find at your local hardware store so I had to place a special order for it.

I check the alignment of the steel rod for the tenth time. The wing tip is permanently attached now and I'm about to permanently set the rod. Everything must be perfect.

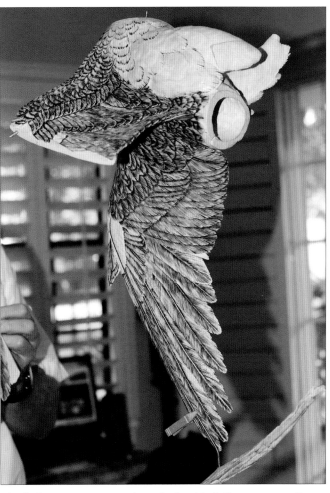

I'm about to commit myself. While the rod is held in place in the wing and body with friction and a clothespin I assemble it once again to confirm that all is exactly where I want it to be in terms of balance and location.

The balance appears perfect. So far, it's "all systems go." This view shows where the rod inserts into the branch and where it projects from the neck opening at the top.

I mix a large amount of Devcon five-minute epoxy with a pinch of fine sawdust from my dust collector into something I call "wood flour." I apply a generous amount into the groove throughout the wing. Then I set in the rod for the final time and securely clamp it in place. There's no turning back. Now I just leave it alone to fully harden up and go celebrate with a cold beer!

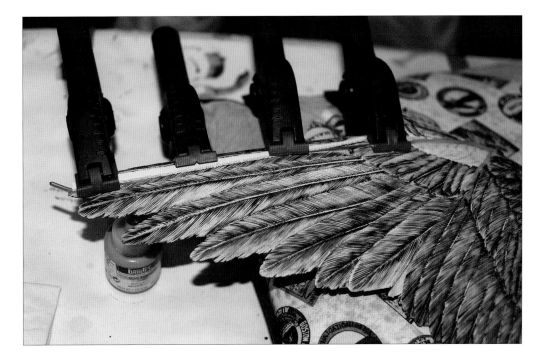

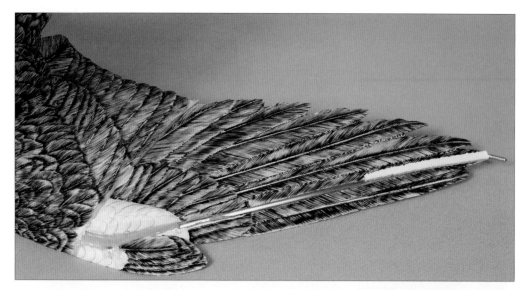

Here's the wing after I've removed the clamps. I used a small scrap of tupelo as a barrier between the rod and the clamps near the tip of the wing. This keeps the clamps from sticking to the rod and perhaps having something break in this fragile area when I remove the clamps.

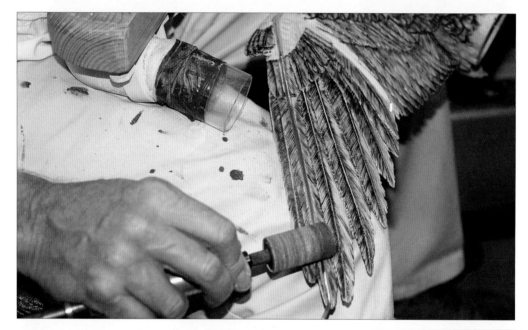

Now comes the task of flattening the steel rod so it looks like a feather shaft. To do this, I'm using a fine sanding sleeve mounted in my Foredom tool and running it at a very slow speed.

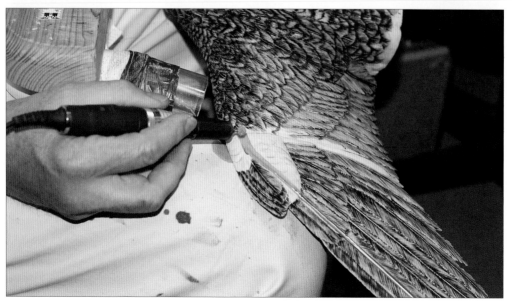

I've filled the cavity on the upper section with some more of the wood flour. Once it's hardened, I smooth it with my Gesswein tool and a small stump cutter.

For the final covering of this area, which must be textured with a wood burner, I'm using Plastic Wood and acetone to blend it all together and form a smooth surface that I can burn.

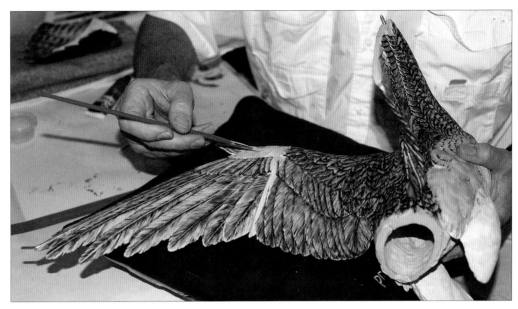

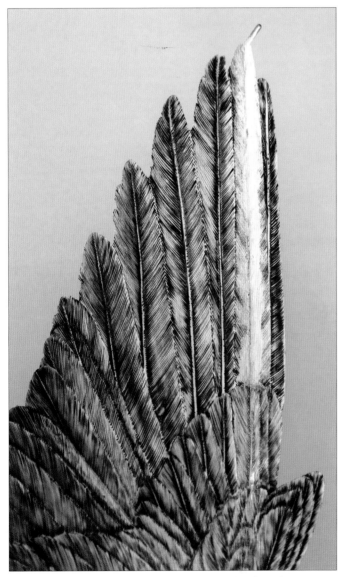

This is the blended area covering the steel rod on the #2 primary feather of the left wing.

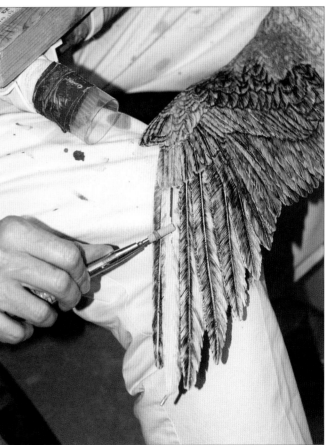

I'm completing the final sanding of the filled trench where the rod sits. I'm using a split mandrel sanding bit with 220-grit paper. If the paper were any finer it would just clog up very quickly and waste time. I will do a final hand sanding with 320- and then 600-grit prior to texturing with a burner. When I texture, I will do it with very low heat on the Plastic Wood sections. Make sure you have a STRONG dust evacuation system, as Plastic Wood dust contains several chemicals that you don't want to inhale!

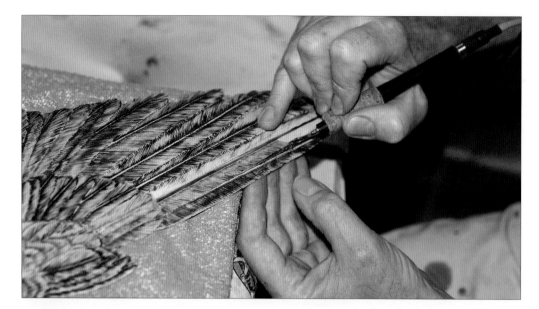

Using a spade-shaped burning tip set at low heat, I complete the texturing of the filled-in repair area. Take your time and strive for clean, well-spaced lines. Consistency in your burning will make it look great!

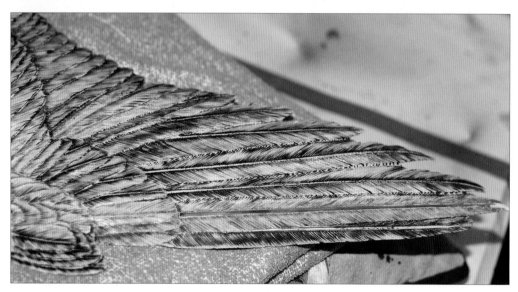

I've finished with the feather. It's ready for painting.

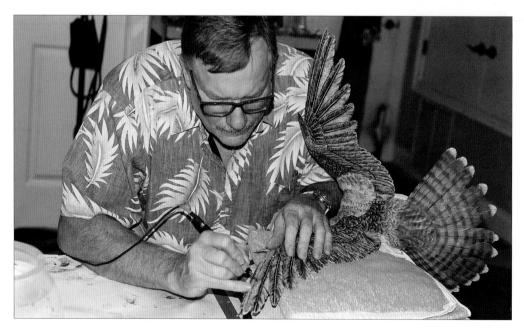

It's always important to go back over areas that you thought were finished. Inevitably you will notice small things that require attention.

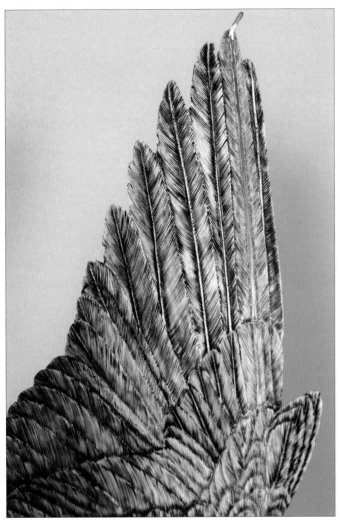

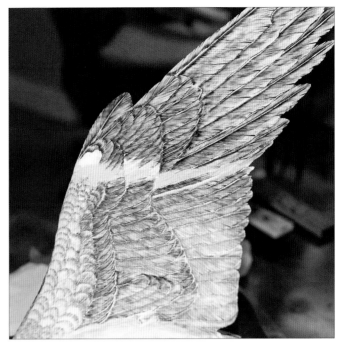

In preparation for texturing, I blend all the joints until they look like one continuous surface. These are critical areas that require special attention so take your time and do it right!

Once painted, the steel rod will look just like another feather shaft.

Here's the top area of the wing permanently attached to the body and fully blended.

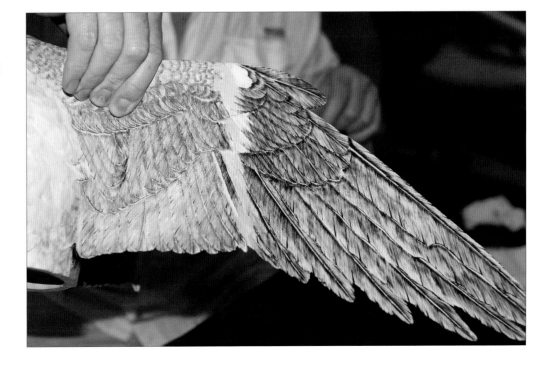

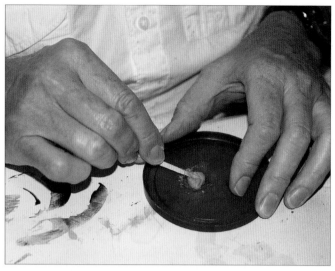

When mixing the epoxy, I've found that using the flexible top from a can of peanuts or coffee works great. Be sure to mix it thoroughly before you use it.

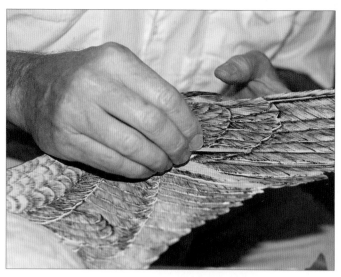

I'm using a wooden large flat toothpick to apply the epoxy to the joint.

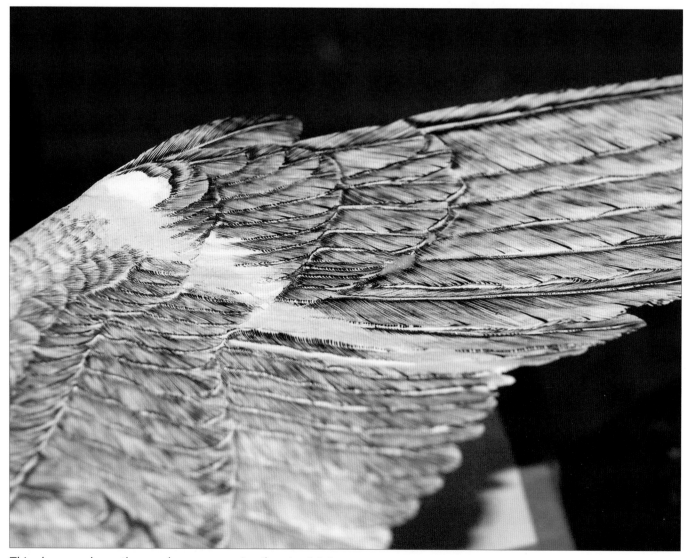

This close-up shows the wooden scar covering the wing joint.

Before texturing the joint
I sand it smooth. I use a
split mandrel with 220-grit
sandpaper to sand the joint.

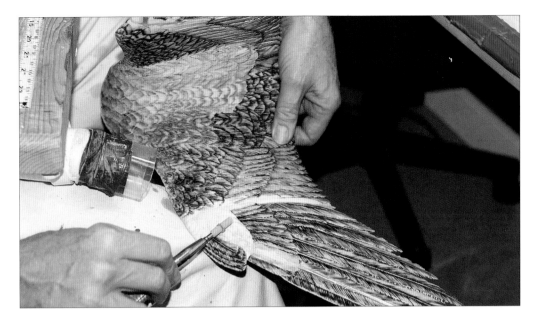

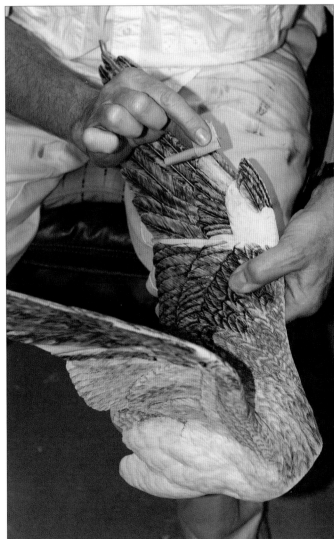

Next I wrap some 320-grit sandpaper around a small round
rubber hose and gently hand sand the area until I get it as
smooth as possible.

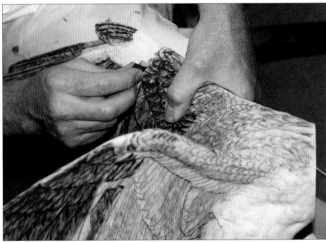

My final sand out with 600-grit paper gets it really smooth.

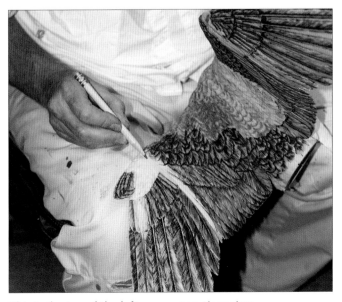

This is the top of the left non-supporting wing.

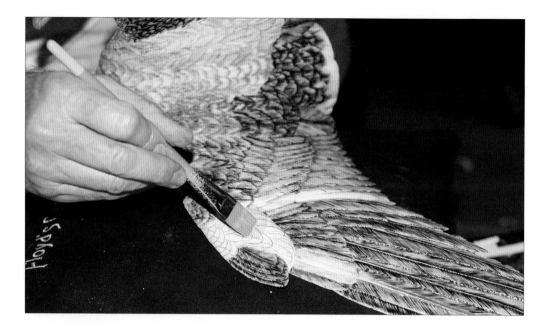

More blending. Here I'm using a stiffer white bristle 3/4" round brush to apply gesso to a heavily textured part of the wing's leading edge. I prefer a stiffer brush so I can work the gesso into all the nooks and crannies.

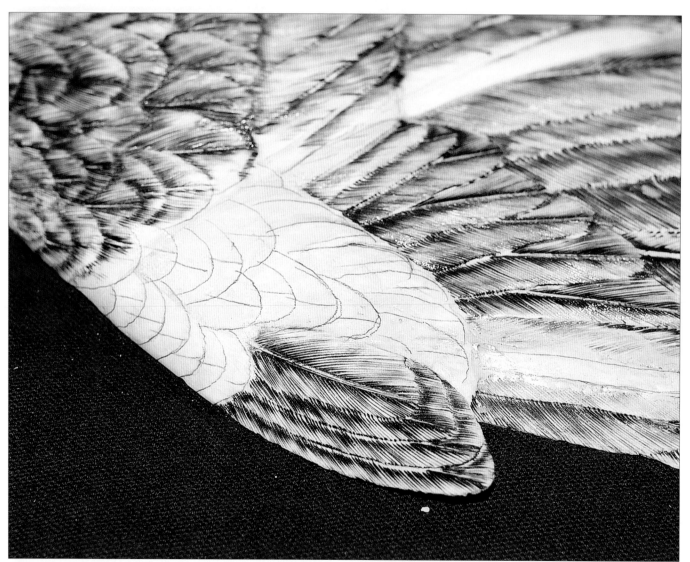

Once I've finished sanding, I draw in the feathers and get ready to texture these areas with a wood burner set at low heat.

PAINTING THE FALCON

From the moment tool touches wood you begin your journey of transformation. Every decision made, each cut taken, will take you one step closer to coaxing a soft, life-like bird out of a lifeless block of wood.

However, carving is only one of the two creative disciplines you need to create a wooden bird. I sincerely believe it is your skill as a painter that determines a successful outcome. Having judged countless carving competitions around the country during the past 30 years, I've seen some beautifully carved birds ruined by poor paint jobs. On the other hand, I've seen some mediocre carvings brought to life by virtue of great painting.

If you proceed with patience and keep things simple you might be pleasantly surprised with the results.

Let's go!

Dust and debris are the enemies of wet paint. Once applied, acrylic paint acts like a magnet and will attract everything it can until dry. Before I begin painting, I give my studio space a good cleaning. I vacuum the floors and wipe down all flat surfaces and light fixtures with a damp towel.

PAINTING A PEREGRINE FALCON

I paint all my birds with acrylics. I have not noticed a big difference among brand name paints but I do prefer to use Liquitex concentrated color acrylics in the 2-oz. jars with the flip cap.

FOUNDATION

Once I've sealed all parts to be painted with a good quality, non-oil-base penetrating sealer, it's time to apply the acrylic gesso. On the areas which have no burning texture, I apply gesso full strength, with just a drop or two of flow medium added to the pool on my palette. Unless I am doing a black or very dark-plumaged bird, I like to begin by applying pure white gesso. Sometimes, as in the case with the peregrine falcon, I will add color to the gesso. White works well as a foundation. As I layer on multiple wash coats of thinned-down color, the white base reflects light back up through the many layers of pigment, which helps enhance their respective values and makes them appear brighter and more vibrant.

Colors & Brushes

The colors I choose to use are as follows (all by Liquitex):
- White acrylic gesso
- Iridescent white
- Burnt umber
- Raw umber
- Ultramarine blue
- Payne's gray
- Yellow oxide
- Burnt sienna
- Raw sienna
- Magenta

The brushes I use are:
- An Aztek airbrush and a good quality compressor (Iwata makes my favorite and it is available from the Jaymes Company of Forest Hill, Maryland)
- 3/4" oval wash brush
- 1/2" oval wash brush
- #6 pointed sable detail brush
- #1 pointed sable detail brush
- For general purpose I like to use the inexpensive 1" China bristle brushes, available at any local hardware store.

When I begin painting I break the process down into three distinct parts.
(1) Foundation
(2) Coloring
(3) Detailing

On all the burned areas of the body and tops of the wings, I add 30% Payne's gray to the gesso and thin it to the consistency of skim milk. Doing this begins to shift the overall color paradigm to the correct base tone coloration while using the warm brown tones of the wood burning to enhance the individual feather shape and texture.

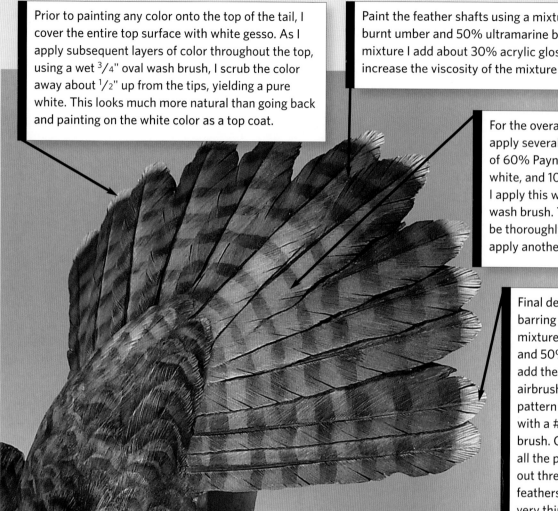

Prior to painting any color onto the top of the tail, I cover the entire top surface with white gesso. As I apply subsequent layers of color throughout the top, using a wet $^3/_4$" oval wash brush, I scrub the color away about $^1/_2$" up from the tips, yielding a pure white. This looks much more natural than going back and painting on the white color as a top coat.

Paint the feather shafts using a mixture of 50% burnt umber and 50% ultramarine blue. Into this mixture I add about 30% acrylic gloss medium to increase the viscosity of the mixture and shine it up.

For the overall base color I apply several thin wash coats of 60% Payne's gray, 30% white, and 10% raw umber. I apply this with a $^3/_4$" oval wash brush. The paint must be thoroughly dry before you apply another coat.

Final details, such as feather barring and splits, are a mixture of 50% burnt umber and 50% ultramarine blue. I add the barring with an airbrush and torn paper pattern and paint in the splits with a #6, top-quality sable brush. Once I've completed all the painting, I will pick out three or four individual feathers and give them a very thin wash of magenta.

I paint the underwings and under-tail feathers with white gesso with an addition of about 20% iridescent white. I've noticed that regardless of the color, the undersides of most birds' wing feathers and underside of the tail have what can best be described as a shimmering quality, so I always add a little bit of iridescence to the paint when I am tackling these often overlooked areas.

After the gesso has dried I use my airbrush to apply a gray color into all the valleys and low spots throughout the bird's body. I set the compressor to about 27 to 30 psi and keep my paint consistency like skim milk. I use a mixture of 50% burnt umber and 50% ultramarine blue. Into this black color I then mix in 50% white (gesso). The result should be a rich medium-tone gray, often called battleship gray.

COLORING

After the bird has been gessoed and all the airbrushing of shade and shadowing is complete I will begin applying layer upon layer of the actual color of the bird until I achieve the desired value. For the peregrine, I use a mixture of 90% Payne's gray and 10% raw umber.

I apply up to 10 thin wash coats of this color onto the upper body, top of head, and top of wings using a $^3/_4$" oval wash brush. I prefer the brush to the airbrush for this action because it lets me drive the pigments deeper into the texturing.

The darker areas, such as the top of the head, wing bars, and wing tips get a mix of 50% burnt umber and 50% ultramarine blue applied as wash coats with the oval wash brush.

DETAILING

Detailing consists of things such as feather edging, feather splits, areas around the eyes and beak, the feet, and overall "tightening up."

Once painting is complete, I lightly spray the entire bird with a matte acrylic spray as an added barrier of protection against airborne dust, grease and especially the UV rays of the sun. Once the bird leaves my studio I have no idea where or under what conditions it will be displayed so I like to send it off with as much protection as possible.

SPLITS

When painting an area like the tail I always paint the feather splits last. Properly done, splits can add a great deal of animation and depth to an area. I've found that carbon black works best when applied with a fine pointed #1 brush. This is one of the rare times during the painting process when I will use black.

TIPS

Once the whole underside has been painted, I go back and brighten up the ends of the feather tips with a #6 sable brush and a mixture of white and 10% raw umber. I'll use this same whitish mixture for all the feather ends throughout the falcon.

FEATHER SHAFTS

Paint the feather shafts with a solid coat application of white mixed with a little (5%) yellow oxide and 5% burnt umber. Once dry, brush on satin polyurethane to provide a bit of sheen.

UNDER-TAIL COVERTS

Contrasting with the long, stiff tail feathers, the under-tail covert feathers have a soft, lace-like quality. After airbrushing the dark valleys, I use the same mixture for the dark bands that I used on the tail. Once I've put the dark bands onto each individual feather, I use white gesso and paint in fine strokes along the outer edges of each group of feathers.

BANDING

During my years of studying raptors, I'm constantly surprised at how many have heavily banded tails. Using an airbrush with a torn-edge paper template, I carefully spray a mixture of 50% burnt umber and 50% ultramarine blue until I get a rich, dark bar.

The visual power of the under-tail area comes from the unique and structurally different types of feathers found in close proximity to one another. If carved and painted with creativity and attention to detail, the under tail and under-tail coverts of a bird can be a challenging but fun area to do, one that can really make an impact on the overall piece. Before I begin adding any color, I can't emphasize enough how important surface preparation is. I begin by applying a mixture of white gesso mixed with about 30% iridescent white to all the parts, striving for a bright white, slightly reflective surface. Next, using an airbrush with a mid-tone gray color, I deepen all the "valleys," including the lower portion

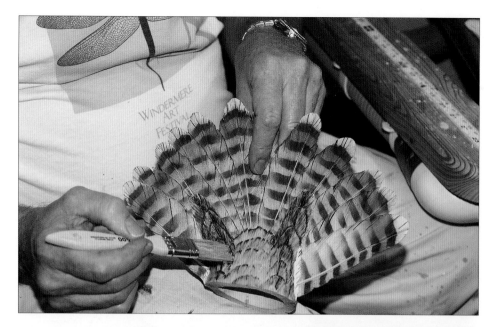

I'm ready to start painting the under-tail coverts of the still-unattached tail section. Here I'm applying the sealer.

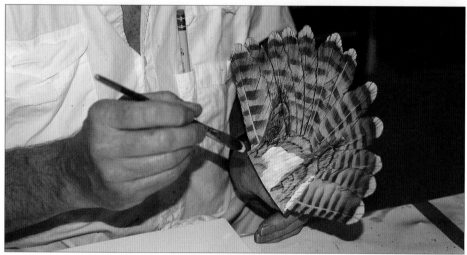

I apply acrylic gesso to the under-tail coverts. Once I've painted the under-tail coverts, the whole unit is now ready for attachment onto the body.

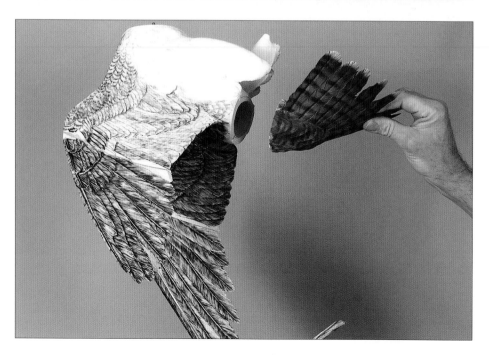

Before attaching the tail I check the attachment angle and location. At this stage in the process I've made all my decisions regarding placement so now it's just a simple case of aligning the pencil marks and gluing things in place. It's important that the epoxy forms a tight seal around the perimeter of the joint.

I'm applying a thick ring of my epoxy mixture around the rim of the opening. I'd better work fast as it begins to set up and harden VERY quickly.

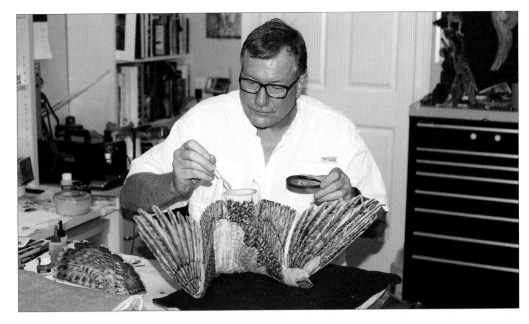

I also apply epoxy to the tail section so both connecting parts have glue on them.

Success! Another milestone has been reached! Due to the quick setting property of the five-minute epoxy, I can safely handle the whole body with tail attached in about 10 to 15 minutes. But, I know it takes at least 24 hours to fully cure so I don't want to press my luck by working the area too soon.

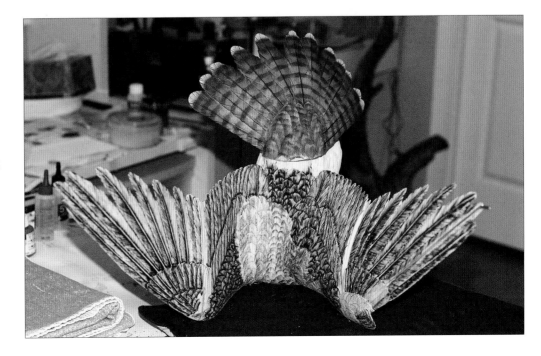

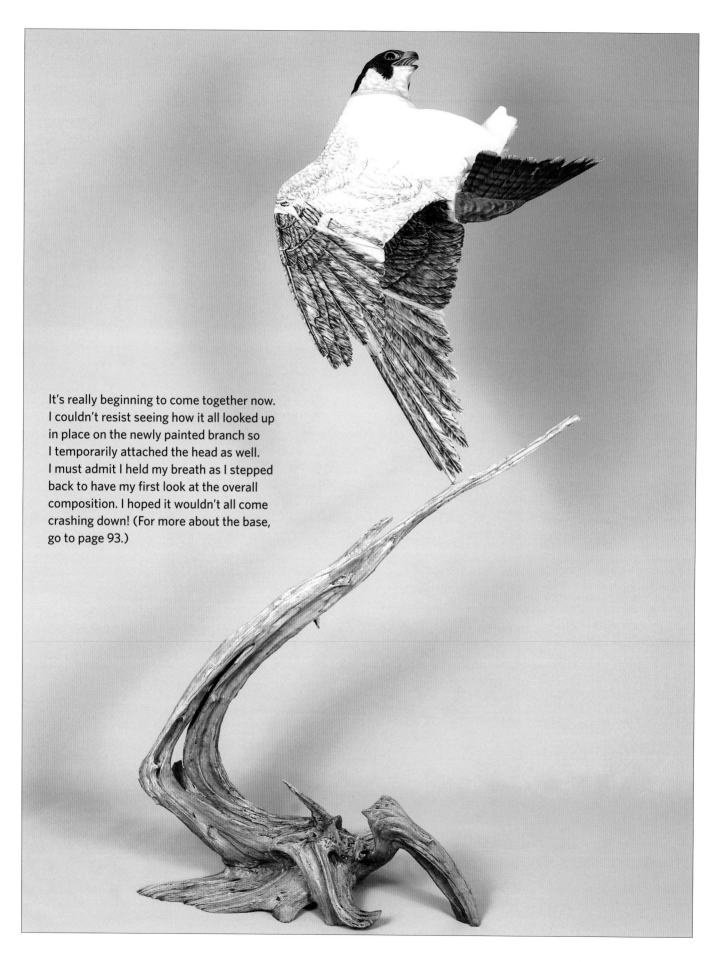

It's really beginning to come together now. I couldn't resist seeing how it all looked up in place on the newly painted branch so I temporarily attached the head as well. I must admit I held my breath as I stepped back to have my first look at the overall composition. I hoped it wouldn't all come crashing down! (For more about the base, go to page 93.)

Using a stump cutter I blend the joint where the body and tail section meet. I use the exact same technique to blend this area as I did for the wings.

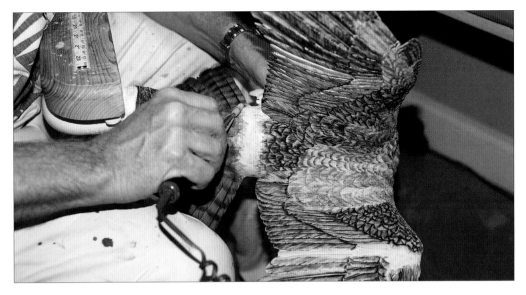

Blending the underside.

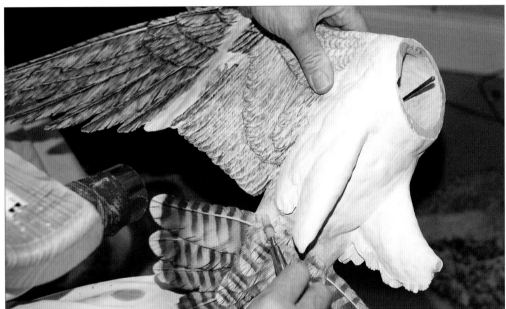

Sanding, sanding, and more sanding! I begin with 220-grit Swiss sandpaper and then switch to 320- and ultimately 600-grit. I then carefully rub the area with my fingers and rely on my sense of touch to determine if it's smooth enough for final texturing.

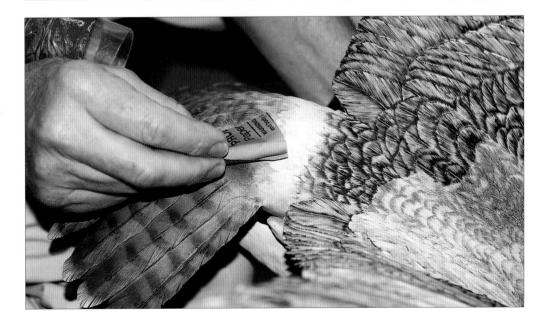

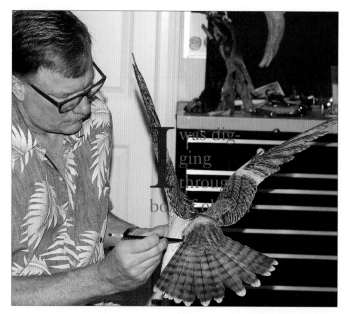

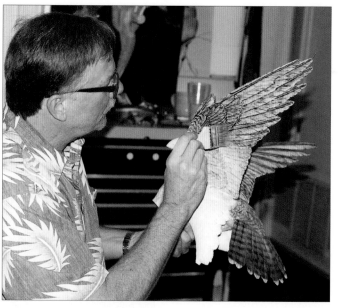

After I've sanded the joint as smooth as I can make it, I apply sealer to the joint and allow 24 hours for it to fully dry.

I move to the underside of the left wing and apply sealer to the newly textured areas. The Fabulon sealer I use is formulated to penetrate into the wood so I apply it with a bristle brush quite thickly and allow it to sink into and seal the bare wood, joint and all.

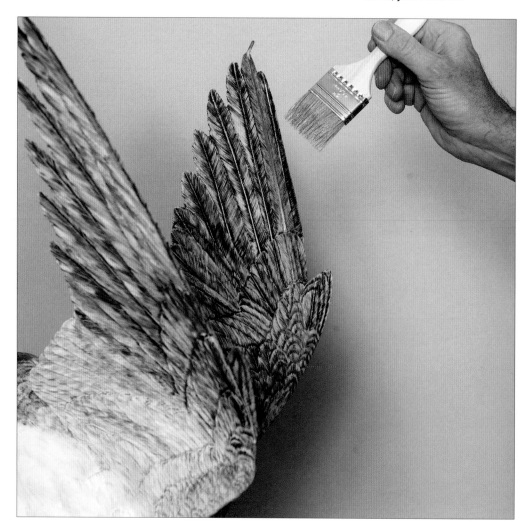

I seal the whole area in preparation for painting. As a rule, I like to apply the sealer in the afternoon and let it fully dry overnight. The instructions on the can state that it dries in 30 minutes but I always like to play it safe.

Here I'm applying gesso to the top of the left wing. A careful application of the white gesso will provide a good consistent surface to begin laying in the wash coats of color.

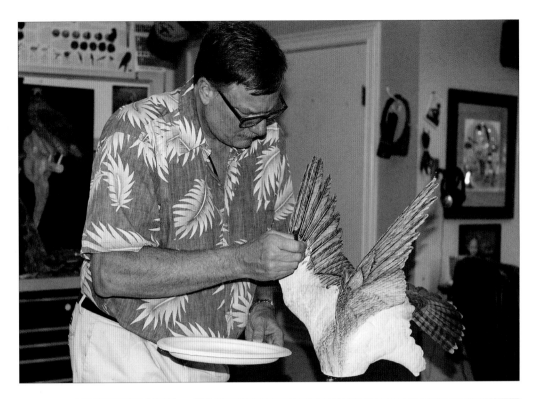

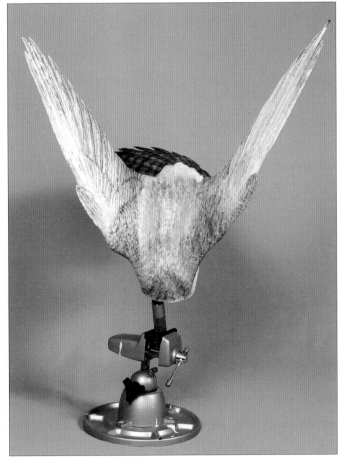

I decided to paint the entire body before I attach the head. This made it much easier to hold the bird with a well secured holding device screwed into the body cavity. I enjoy painting. It's clean and quiet and I know the finish line is near!

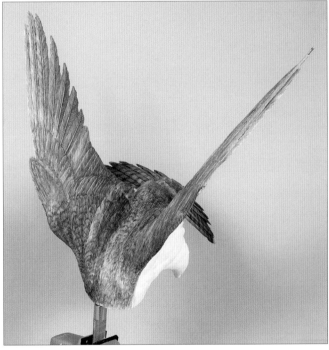

I've been applying successive wash coats of Payne's gray over the entire back and top of wings. You must avoid touching any surfaces that will be painted because your fingers have lots of oil on them.

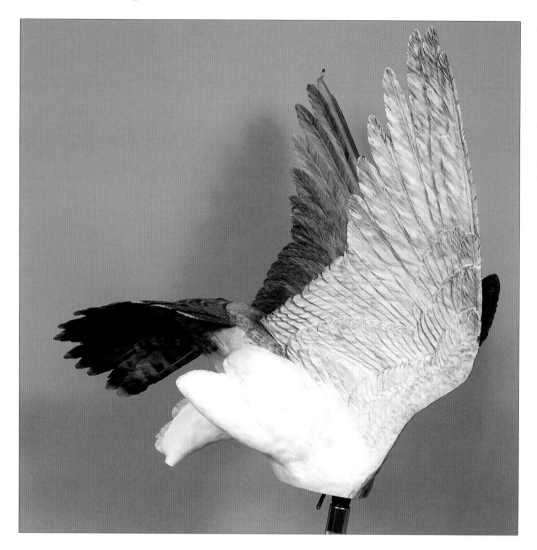

I've applied a thin wash coat of iridescent white to the underwing areas to intensify the silvery white appearance I see in the live falcon.

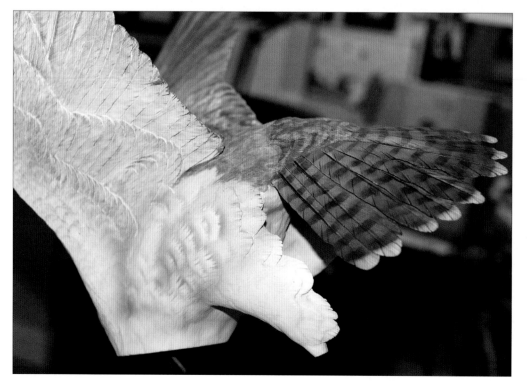

Nothing works as well as the airbrush to create that beautiful illusion of softness and the subtle shade and shadowing in the feathers of the underwing areas.

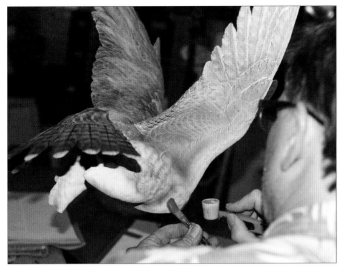

I'm using a 1/2" oval wash brush as a pattern as I airbrush in the shade and shadowing of these very soft feathers. I press and spread the end of a dry brush onto the surface of the wood and the splits of the brush form a very soft and varied edge that looks like real feathering.

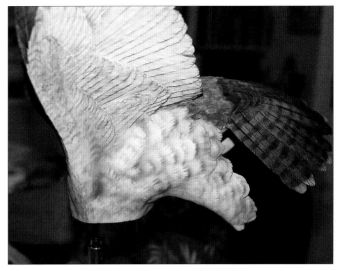

Here is the final result of the airbrush shadowing, showing the extreme softness you can achieve. This "brush pattern" technique works so well!

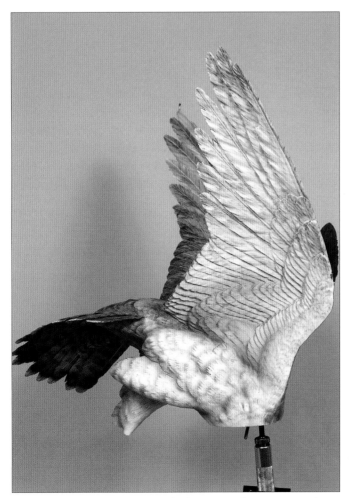

I'm done with the base tone shadowing and am now ready to begin some feather patterning and details. The best has yet to come as I *love* to detail the feathers!

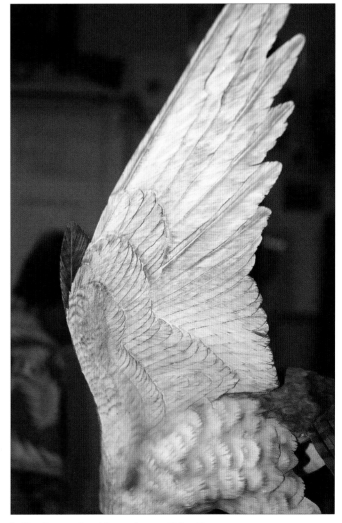

Left wing underside and armpit feathers.

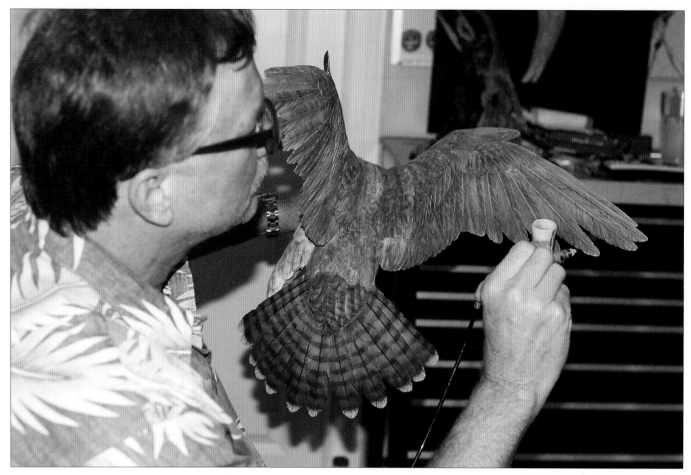

On the top of the right wing I build up more and more wash coats of Payne's gray. Keep your wash coats very thin and watery and apply them with a ³/₄" oval wash brush. In this image I'm using an airbrush to darken the outermost primary tips. I'm using a mixture of 50% burnt umber and 50% ultramarine blue thinned with water only. It looks black once mixed. To give the impression of the dark tips emerging from the blue wing body, simply reduce the amount of finger pressure on the trigger and move your airbrush away from the surface of the feathers in a sweeping motion from the tip to the front of the wing. With a little practice, you'll develop a rhythm. This is not a wash coat but a gradual darkening done with several passes of the airbrush.

I put in the darker barring patterns using an airbrush and a mixture of 50/50 ultramarine blue and burnt umber. A ragged, torn piece of paper works great as a pattern when putting in the barring. Be careful not to apply the airbrushed paint too thickly or it will drip or look too opaque. I vary the pressure I'm applying to the trigger of the airbrush to shift the intensity of the applied color. This is a subtle technique which will require some practice.

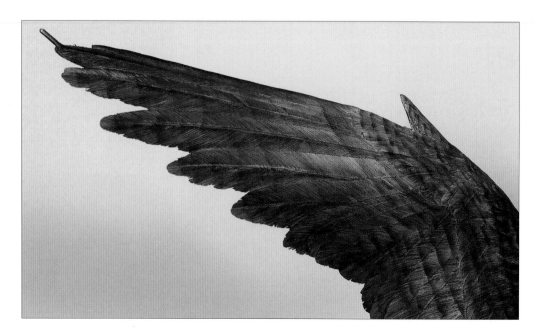

The plumage patterning found throughout the upper parts of an adult peregrine falcon can appear bewildering at first glance. Dark blotches, bars, and banding assembled in haphazard regimentation against a battleship gray backdrop provide a tantalizing topcoat to the bird's sleek, muscular frame. In order to proceed accurately, one must mentally "disassemble" the elements and advance from light to dark. After applying several thin coats of white gesso colored with about 10% Payne's gray to all the burned feathers of the top of the tail, body, and top of the wings, I settle in for a whole lot of airbrushing. I'll do all the dark markings with a mixture of 50% burnt umber and 50% ultramarine blue thinned to an ink-like consistency, with a couple of drops of flow medium added to retard drying.

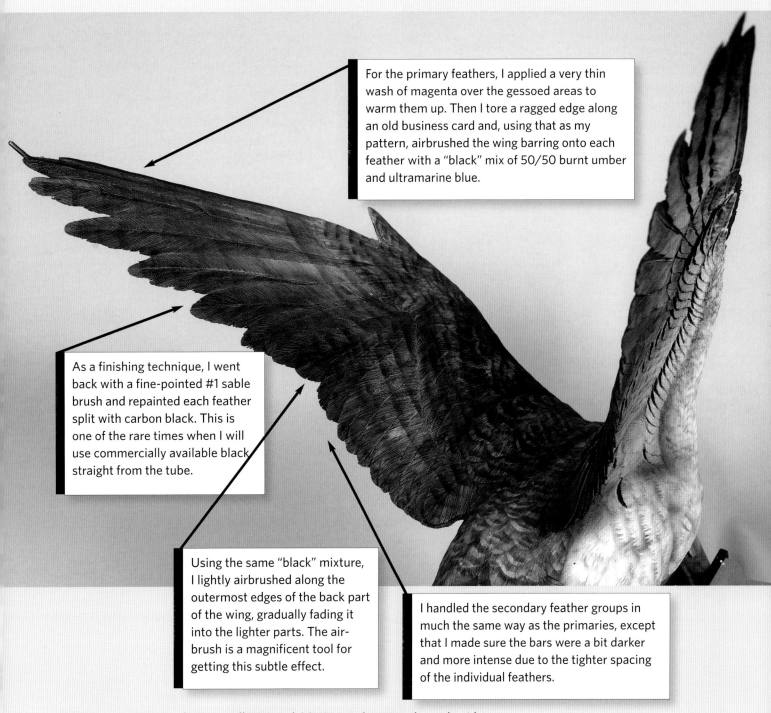

For the primary feathers, I applied a very thin wash of magenta over the gessoed areas to warm them up. Then I tore a ragged edge along an old business card and, using that as my pattern, airbrushed the wing barring onto each feather with a "black" mix of 50/50 burnt umber and ultramarine blue.

As a finishing technique, I went back with a fine-pointed #1 sable brush and repainted each feather split with carbon black. This is one of the rare times when I will use commercially available black straight from the tube.

Using the same "black" mixture, I lightly airbrushed along the outermost edges of the back part of the wing, gradually fading it into the lighter parts. The air-brush is a magnificent tool for getting this subtle effect.

I handled the secondary feather groups in much the same way as the primaries, except that I made sure the bars were a bit darker and more intense due to the tighter spacing of the individual feathers.

The top areas are now almost totally painted. It's time to focus on the underside.

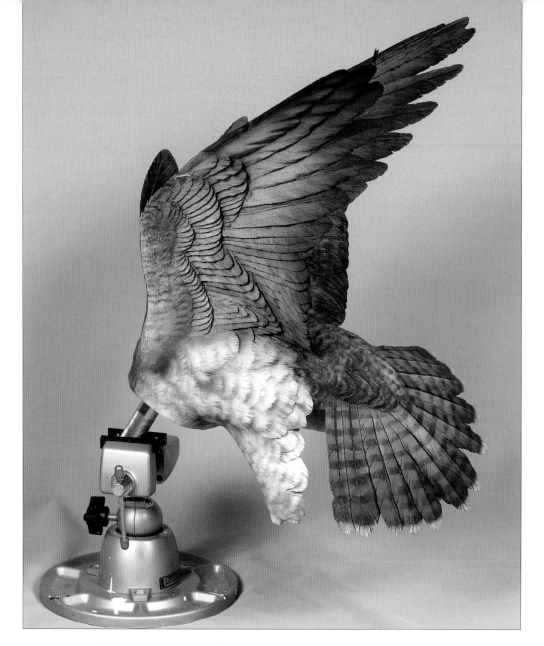

The first step is to darken the outer edges of the major flight feathers and have them subtly fade into white. This is easily done using an airbrush. This is a nice view of the left side midway through the painting process. Note the softness and feather flow.

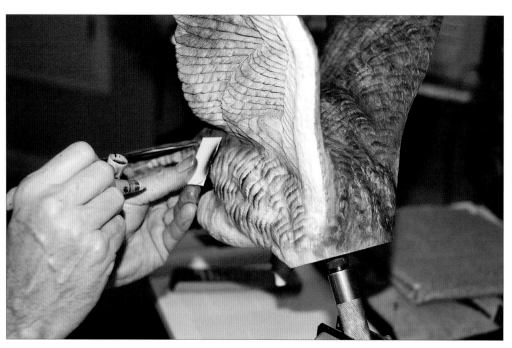

I've made several patterns out of a heavy absorbent paper as I begin airbrushing in the distinct black feather patterns along the right side of the falcon's body. I'm using a mixture of 50% burnt umber and 50% ultramarine blue.

Here I've put in all the black patterns. Notice that I vary their size to prevent the end result from being too repetitious and visually boring.

If I find that I've gone too dark on any area, I can scrub away any unwanted paint with alcohol and a stiff brush.

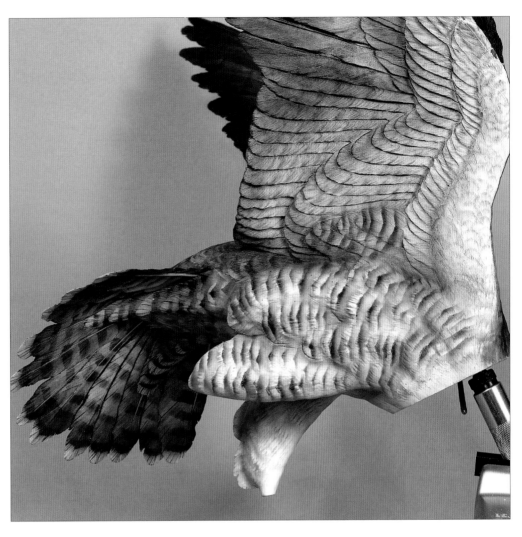

To create the faded white barring on the underwing primaries, I use the alcohol scrubbing technique to bring up the white barring. Do this VERY carefully as you sure don't want to scrub down to the raw wood!

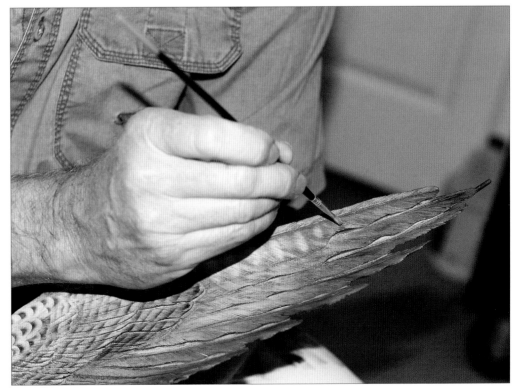

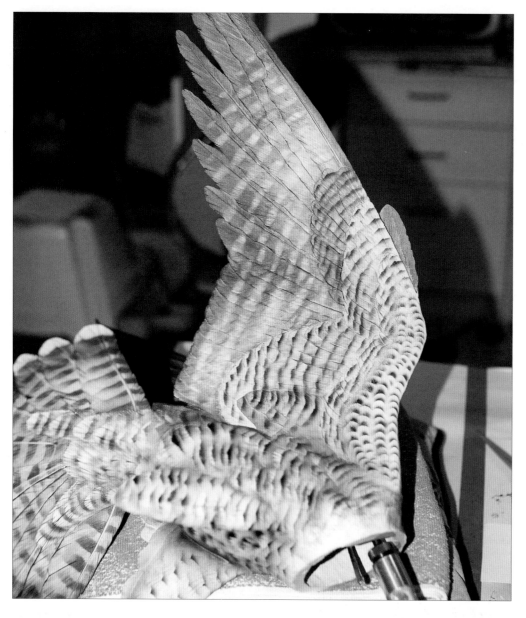

This subtractive technique can be very effective, as you can see in this photo.

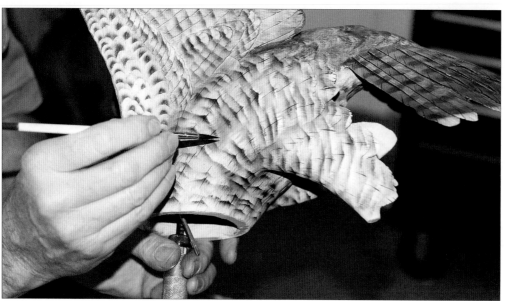

I'm using a #6 round sable detail brush to paint in the subtle edging on each body feather. I'm painting with a mixture of 90% gesso and 10% raw umber. It requires hours and hours of tedious brushwork to accomplish this correctly. Don't rush it!

The stark, cryptic black and white patterning found throughout the undersides of an adult Peale's peregrine falcon reminds me of the clothing worn by prisoners of long ago. That sharp contrast can be daunting and difficult to create on the hard textured surface of a wooden bird. With the exception of the flight feathers (tail included), I have chosen to leave the surface untextured. That's right...no burning or stoning! This gives me much more freedom with my brushwork as I strive to show groupings of feathers shifting collectively as if straining in flight and being buffeted by the wind. I first painted the entire area with up to four coats of white gesso mixed with about 30% iridescent white. I then deepened the contoured hills and valleys with an airbrush mixture of 30% burnt umber, 30% ultramarine blue, and 30% white gesso.

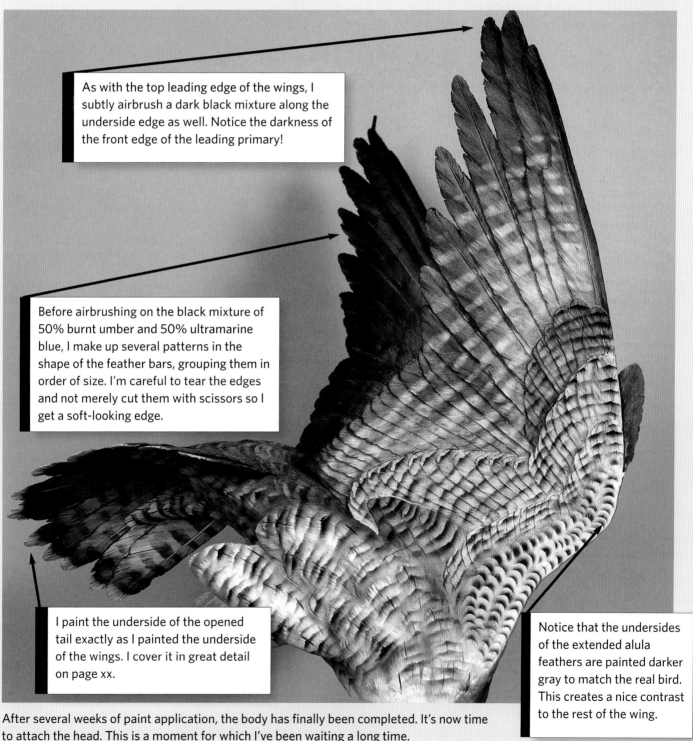

As with the top leading edge of the wings, I subtly airbrush a dark black mixture along the underside edge as well. Notice the darkness of the front edge of the leading primary!

Before airbrushing on the black mixture of 50% burnt umber and 50% ultramarine blue, I make up several patterns in the shape of the feather bars, grouping them in order of size. I'm careful to tear the edges and not merely cut them with scissors so I get a soft-looking edge.

I paint the underside of the opened tail exactly as I painted the underside of the wings. I cover it in great detail on page xx.

Notice that the undersides of the extended alula feathers are painted darker gray to match the real bird. This creates a nice contrast to the rest of the wing.

After several weeks of paint application, the body has finally been completed. It's now time to attach the head. This is a moment for which I've been waiting a long time.

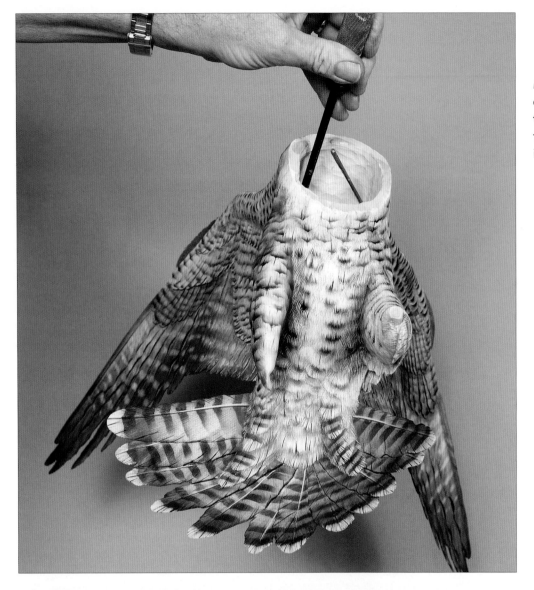

My last look to make sure everything is ready! Notice the end of the support rod from the wing as it extends into the body.

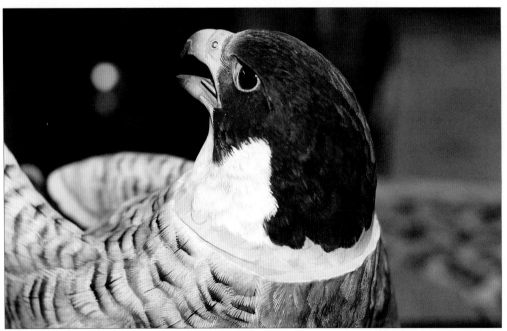

Attaching the head is perhaps the most important part of the whole operation so I take my time. I have already made the critical decision about the head angle so now it's just a question of gluing it all together and holding it in place until the epoxy sets, about six minutes.

I mix and apply the epoxy to the areas I'm about to join. The back of a Stan Shuman chair makes a perfect support at this point in the process. I've used a large, folded bath towel for more support.

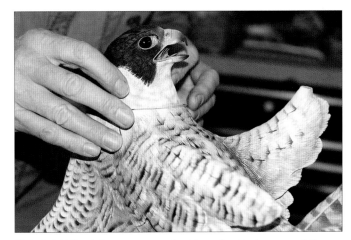

This is it! The falcon comes alive! I prefer that some of the epoxy oozes out from the joint, which tells me I have a good, tight fit.

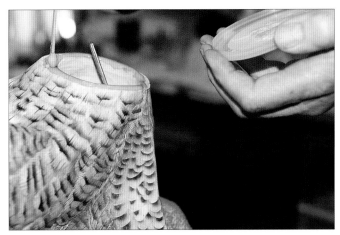

Spread the epoxy carefully to make sure the joint is sealed up perfectly.

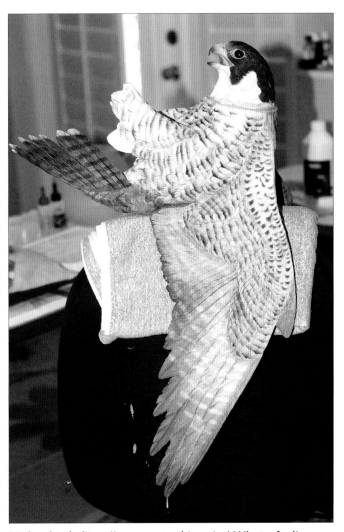

It's hard to believe I've come to this point! What a feeling of complete satisfaction to know it's all coming together the way I had dreamed it would. This is the culmination of four solid months of hard work. Some days I worked up to 15 hours on this project.

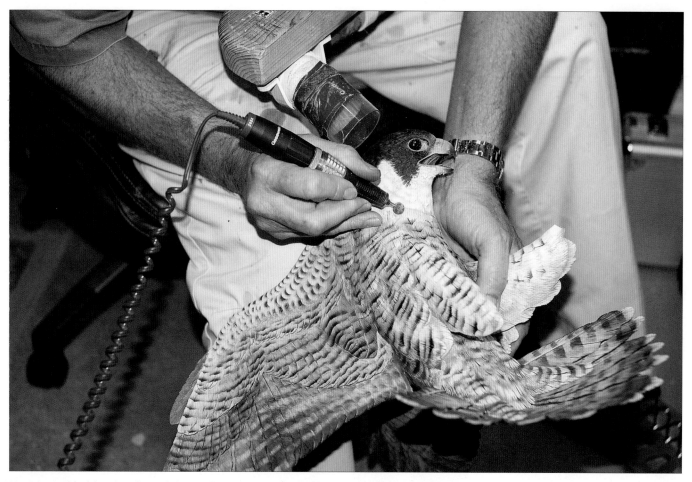

Now I need to blend and sand the neck joint smooth to create a seamless transition.

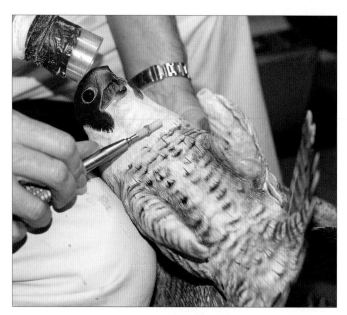

Using a split mandrel and 220-grit sandpaper, I am running my Gesswein tool at slow speed to smooth out and blend the joint.

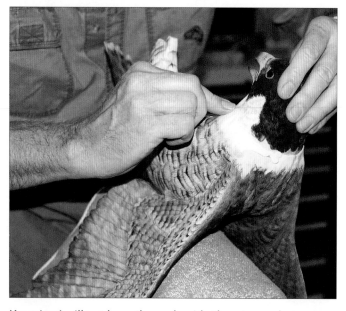

Knowing I will not burn the underside throat area, because these throat feathers are more like soft rabbit's fur than actual feathers, I will rely on my painting skills to recreate the extreme softness found in this region. I mix some A+B epoxy putty to cover the joint. Nothing works quite as well as a wet index finger to blend the sides smooth.

The Importance of Feet

Sometimes bird carvers will get so obsessed with things like feathering, head and eye placement, and wood burning that they almost treat feet like an afterthought. Properly done, feet can be one of the most expressive parts of the entire carving and they must be well designed and accurate. I've learned this the hard way and when I look back on several of my earlier works, I realize that I should have devoted a lot more time and effort to get the feet right. The feet of all my birds now get the respect they so richly deserve.

Whenever possible, I prefer to carve my feet out of wood. The great John Scheeler used to do this and I thought he was nuts, but over the years I've come to see the benefits of doing it this way. It's even more important for this peregrine. It will be in flight so weight—or lack of it—will be an important factor.

Feet do pose a challenge. Except for the beak, a bird's feet are completely different from any other part of its anatomy. Bird feet possess a reptilian quality. Adding to the complexity of the task, in some carvings they support the entire bird and therefore must be strong as well as expressive and good looking.

Using my live bird measurements, I create profile patterns of the foot, with only the middle and rear toe, on a thin piece of cardboard.

I cut good clear-grain tupelo to a thickness of about $3/8$ of an inch in preparation for carving the feet. I'll carve only the leg, middle toe and talon, and rear toe and talon from one piece.

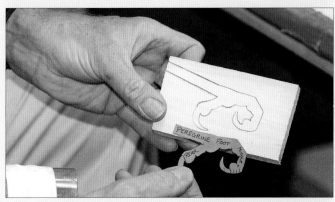

I've traced the pattern onto the wood, with the grain running in the direction of the leg shaft. I'm using tupelo so grain direction won't make much of a difference but, being an old, experienced woodworker, I thought it was the right thing to do.

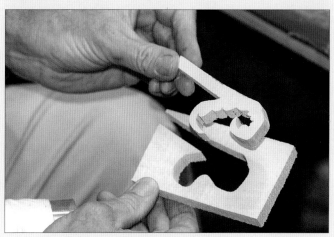

After some time with the band saw, it's just like a puzzle piece perfectly cut from the board and ready for carving and detailing.

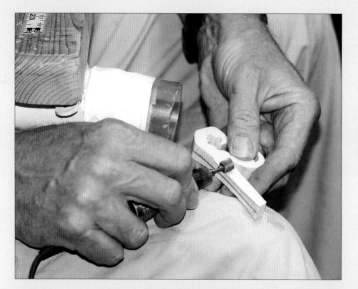

Establish a centerline around the whole foot and keep it throughout the whole carving process. My cutter of choice is a $3/8$" stump cutter running at about $1/2$ speed (20 to 25,000 rpm) in my Gesswein tool. Working near the front of my dust collecting nozzle, I begin by rounding the leg shaft and establishing the exact thickness.

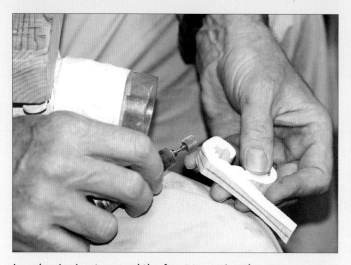

I am beginning to round the front toe using the stump cutter.

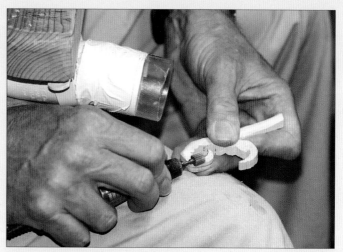

I'm slowly shaping and sculpting the toes and talons using the same stump cutter. It's a very versatile tool and I do a lot of carving with it.

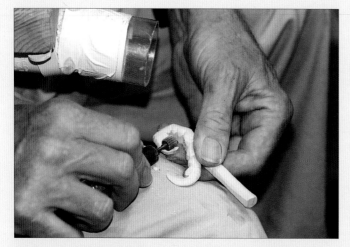

I have to be careful when I work on the thinner parts of the front of the toe and talon so I don't chip off any important pieces.

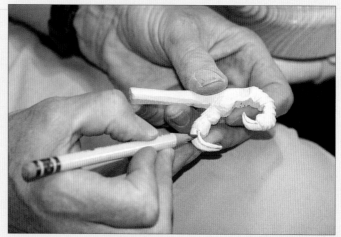

Here I'm refining the shape of the talon by first drawing the lower portion with a sharp pencil. I am doing more and more refining of the talon and the scales that form the top of the toes.

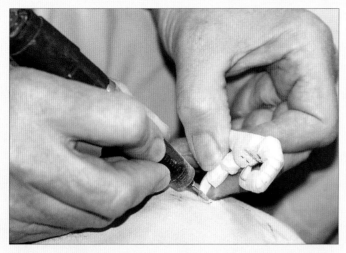

Here I'm using a small pointed diamond cutter to shape and form the sharp talon. When I am using this type of cutter, I crank the speed up to 55,000 rpm. As I proceed, I sand completed areas smooth with 220-grit sandpaper.

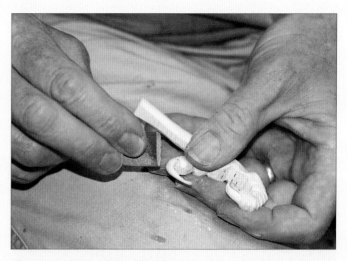

The rear talon is almost finished. I'm doing final sanding with 320-grit sandpaper. This technique is not difficult to do and with a little practice you'll be pleased with the results.

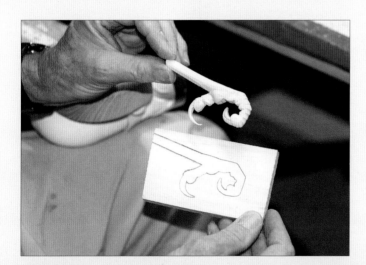

From block of wood to carved foot (minus two toes) in about 30 minutes! The foot structure is so complex I find it easier to carve the outside and inside toes separately. I use 3/16-inch thick Tupelo. After detailing, I attach the toes and talons to the main leg section with five-minute epoxy mixed with a bit of wood dust. More often than not, you won't get it perfect the first time. Be prepared to devote some time to this until you are 100% satisfied.

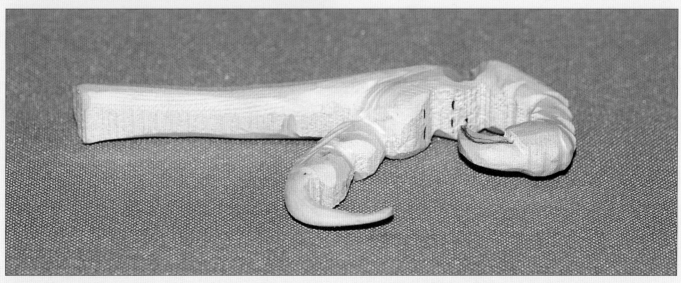

The carved foot ready for the inner and outer toes to be epoxied on. This will be the falcon's right foot when it is totally completed and attached.

PATTERN

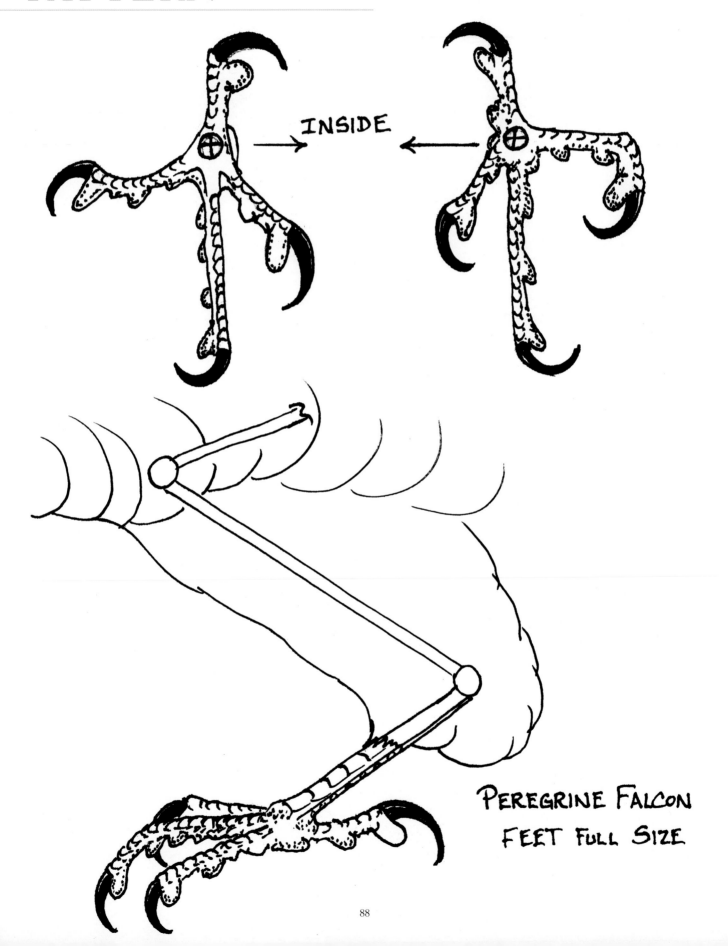

INSIDE

PEREGRINE FALCON
FEET FULL SIZE

With the bird complete, it's now time to attach the legs. I'm drilling a $\frac{1}{4}$-inch hole about $1\frac{1}{2}$ inches deep into the tarsus to accept the $\frac{1}{4}$" leg rod.

I've attached the right leg and solidly glued it into place.

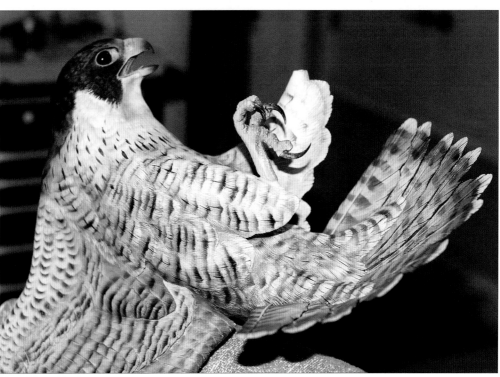

The left foot will be the one grabbing the teal so it will need an extra strong steel rod for support. Here I'm about to glue it into place onto the left tarsus. Rather than just use the same copper rod as the other non-supporting leg, this rod is some more of the #304 stainless steel that I used for my main support rod.

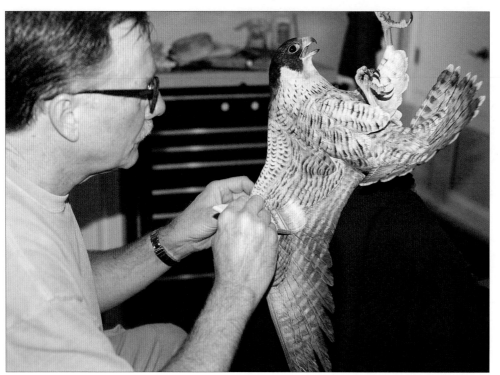

It seems you're never done painting. As a finishing technique for the underside flight feathers, I dry brush white gesso into the edges of the flights. This is what I call "frosting the feathers." Rapid back-and-forth strokes leave a very soft lighter edge on each feather. This is a technique that requires some practice so it's a good idea to experiment on a piece of scrap before you commit to the actual bird.

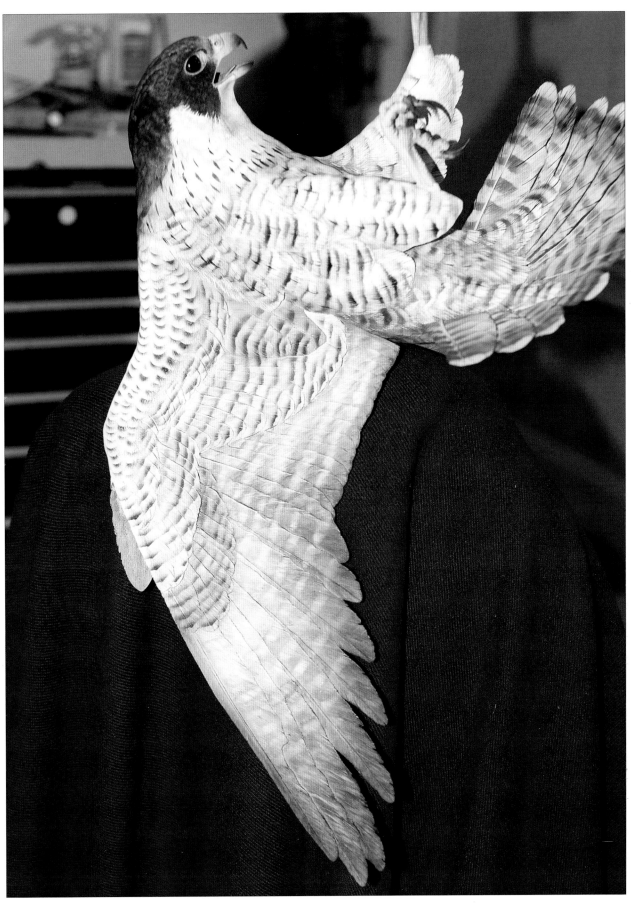

Results of the dry brushing are evident all over the underside of the left wing.

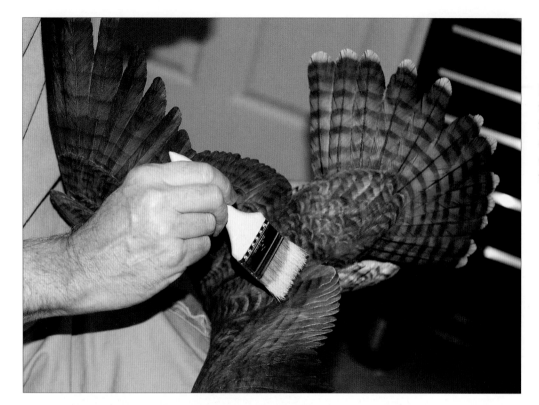

I decided to use the same technique on some of the top feathers too. It made a wonderful difference, especially among the flight feathers.

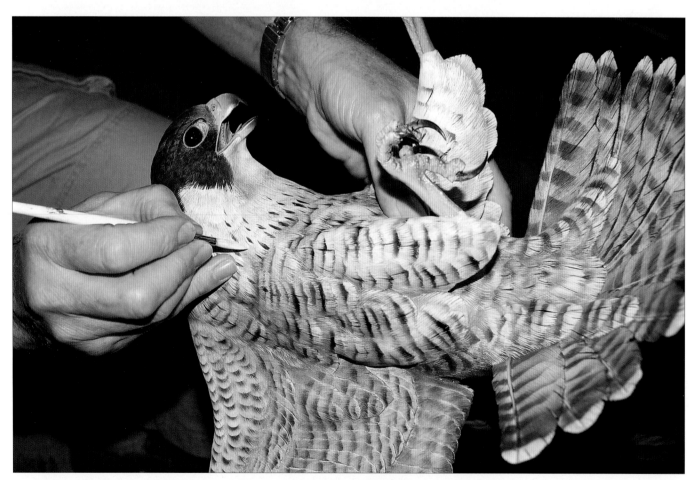

As I inspect the bird, I notice areas that need more attention and detail. Is it ever *really* finished? I do some final touch-up detail with a #1 brush around the chest area. I love to spend relaxing time painting subtle details.

THE BASE

I have a beautiful collection of central Florida driftwood and will sometimes choose one of these pieces to use in my compositions. I've always loved collecting driftwood and draw inspiration from the infinite shapes, colors, and textures of the pieces I find.

The completed base/branch ready for painting. I created this branch because its distinctive shape looks like a pole vaulter's pole. This hopefully will give the impression of the falcon being catapulted into the air as if he were being launched. I've hollowed out the bottom of the base and filled it with lead shot for stability. I mix the #6 lead birdshot into a mixture of five-minute epoxy and pour the heavy slurry into the pocket to harden.

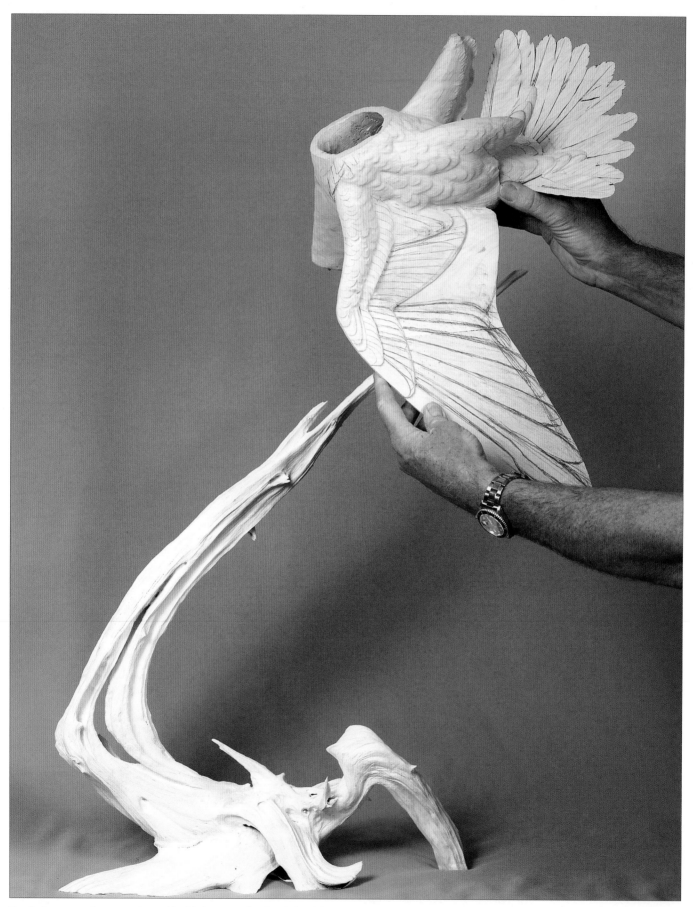

For balance and comparison, I held the main body of the falcon up to the branch for the first time.

PEREGRINE FALCON

THE TEAL

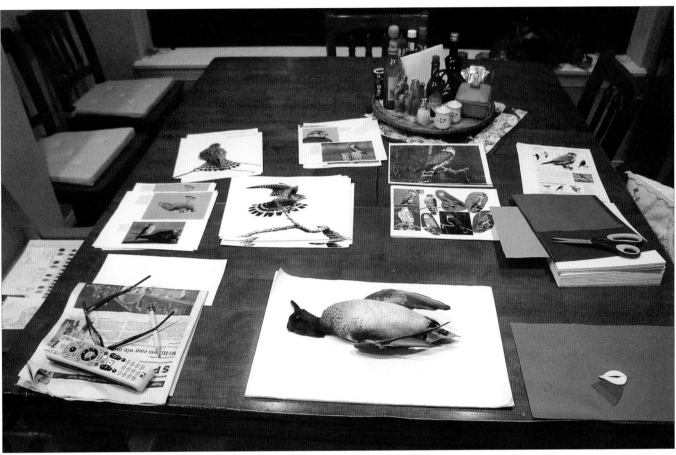

I am preparing to draw up patterns for the falcon's prey. In the foreground is a perfect specimen of a drake green-winged teal. Nothing ensures accuracy and detail better than working with the actual bird. I will measure and sketch the teal to make my patterns.

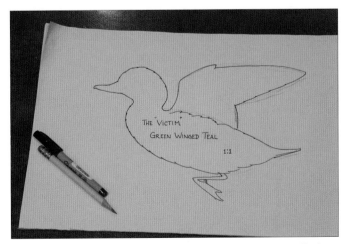

The carving will depict a green-winged teal in evasive flight. Here is the pattern I have drawn based on my measurements. Since the teal is much smaller than the peregrine, I can carve it from a single block of tupelo. I avoid glue joins whenever possible.

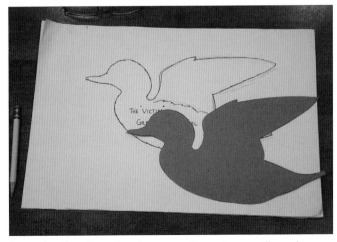

From the sketch on drawing paper I create a cardboard pattern. It's now time to cut wood!

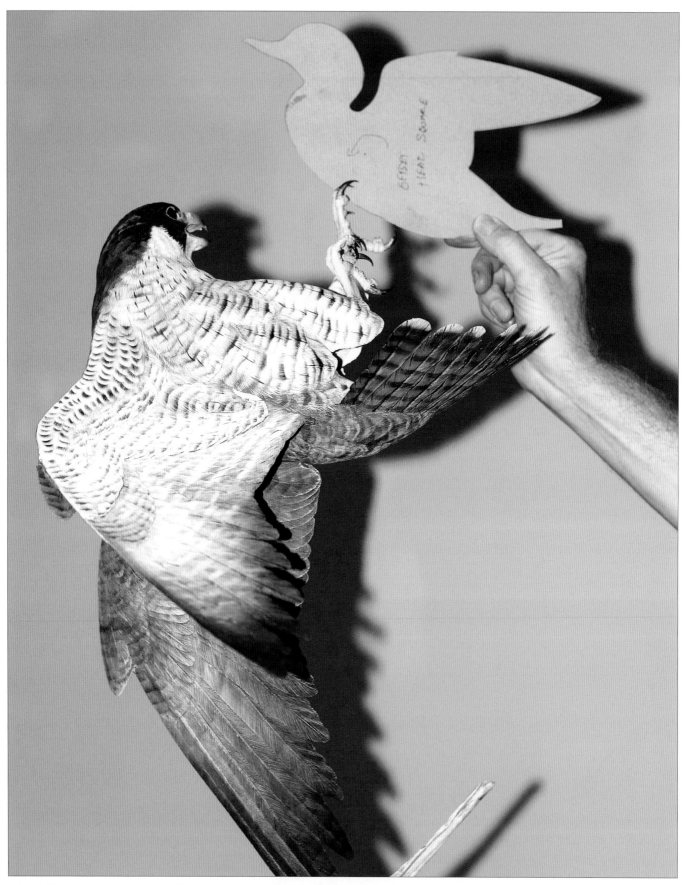

I check the pattern against the falcon to make sure the body position and attitude are what I pictured. I want to give the impression that the teal is in frantic flight as it tries to avoid capture.

PEREGRINE FALCON

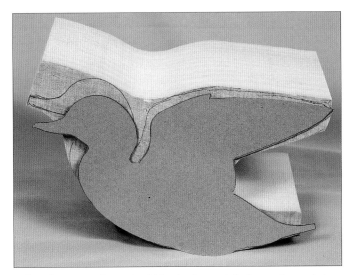

When I cut out the actual block of wood, I always leave lots of extra around the head and neck areas. Inevitably I will make alterations as the carving develops.

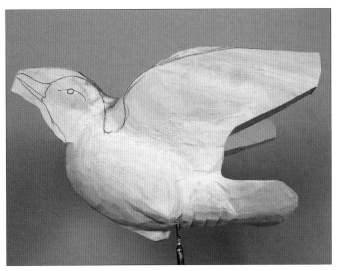

The roughed-out teal begins to take shape. My tool selection for roughing out the flying teal is different from what I used for the falcon. I relied mainly on a series of large-to-medium Typhoon cutters mounted in my Foredom tool for the initial shaping. As the body form became more refined, I did most of my work with a small serrated stump cutter and a variety of sanding sleeves.

After I've roughed out the teal body, I hold it up to see how it looks in relation to the falcon. At this point I'm quite pleased with the results.

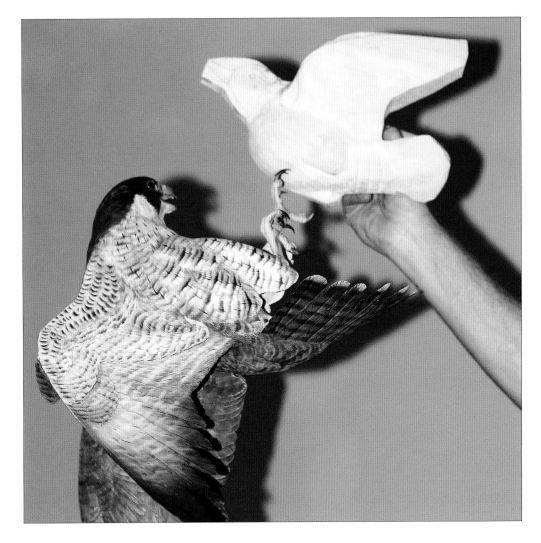

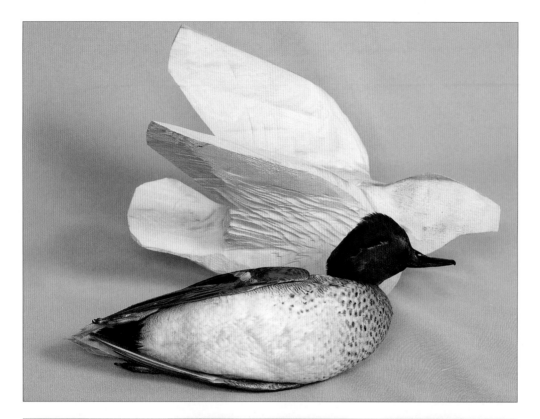

As I move forward I keep checking my results against the real duck, which I store in the freezer. Freezer storage preserves the rich colors of the feathers and slows down desiccation, which often alters the size of the body.

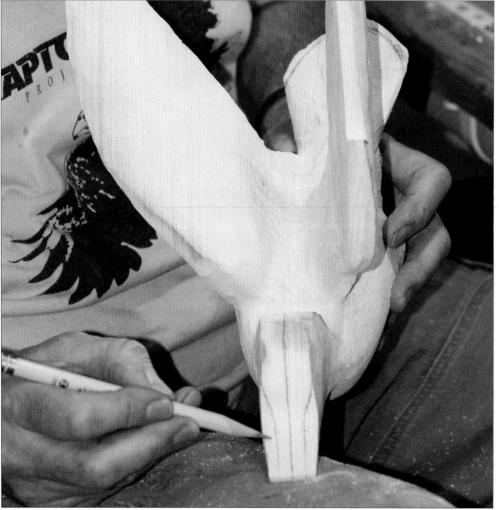

Narrowing down the head and beak. Note the importance of the centerline as I work. Always keep it in place and redraw it as often as you need to.

This view of the flying teal shows the approximate angle I will want the duck to have once I attach it to the falcon. Offsetting the body axis adds to the feeling of motion. When depicting birds in flight one must try to avoid right angles and any sense of stability. The physical exertion required to maintain flight and fight the force of gravity means that each and every muscle in the bird's body is working in perfect harmony.

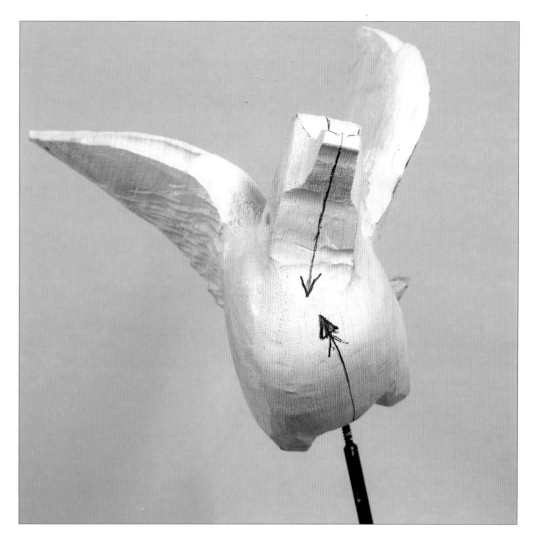

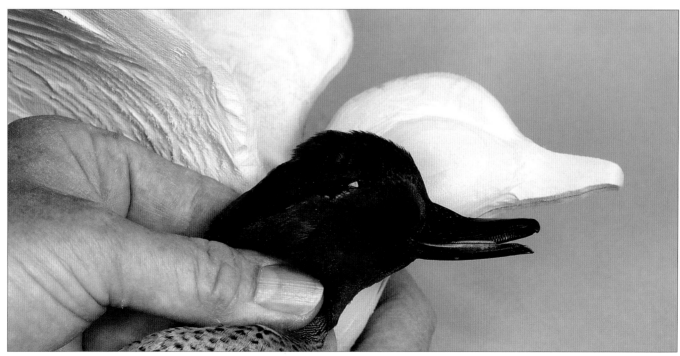

As I move forward I cross-check the head and beak against the actual duck. Thank goodness for my good friend Rich Smoker, who found me this beautiful drake green-winged teal to use as reference.

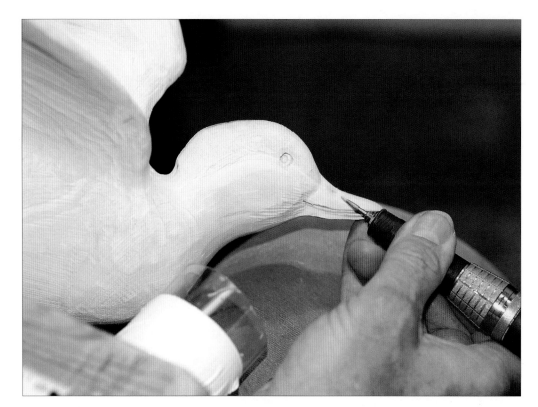

I detail the beak with my Gesswein tool and a pointed diamond cutter.

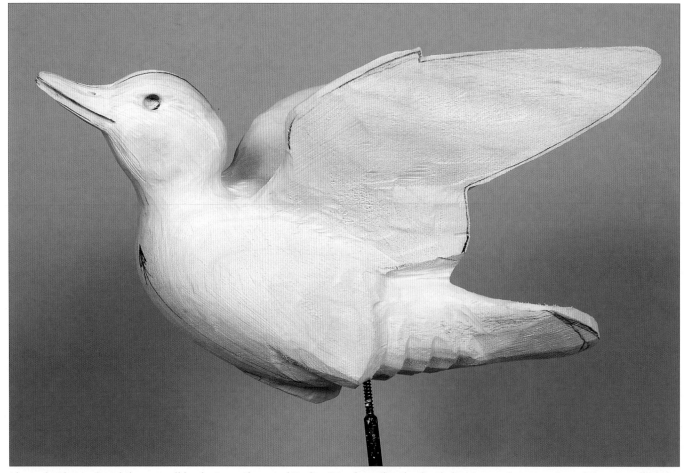

I have further refined the overall body. I use the word "refine" to describe the final shaping and contouring of the overall bird in preparation for feathering.

Once I drill the eye sockets with a 10 mm pointed wood drill bit, I am ready to shape the socket area and set the eyes. Supplied by Tohickon Glass Eyes, they are 10 mm, #115 medium brown with small pupils.

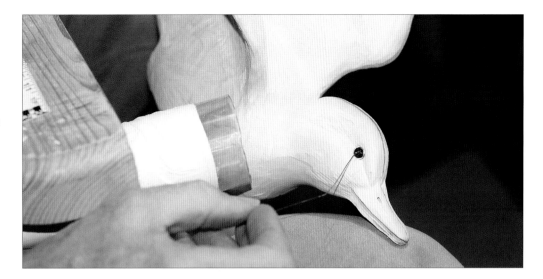

The dotted line indicates the area where I will cut away a panel to get access to the body cavity. I will do this, using great caution, on my band saw with a new, sharp, ¼" skip tooth blade. The blue masking tape is holding the lower mandible in place until I permanently attach it. I like to use the blue tape as it doesn't blend in with the wood.

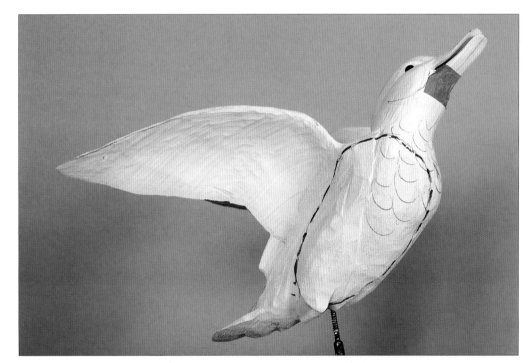

Holding on tight, I make a smooth clean cut along the dotted line I had drawn. Off comes the panel.

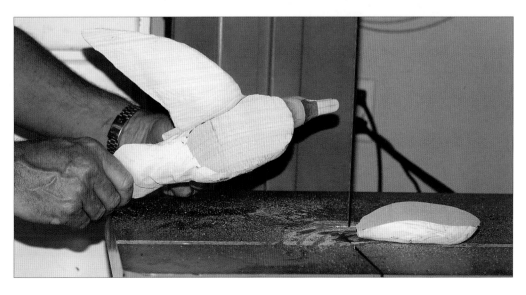

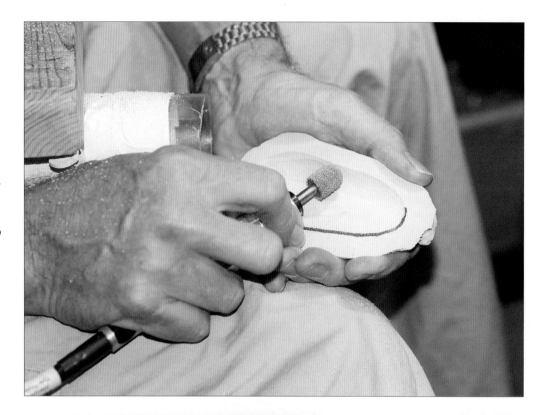

I begin hollowing out the inside of the panel using a round-tip, coarse-tooth Kutzall cutter mounted in my Foredom tool. I really like using this particular cutter for this type of application because it cuts efficiently and quickly. Keep a tight grip!

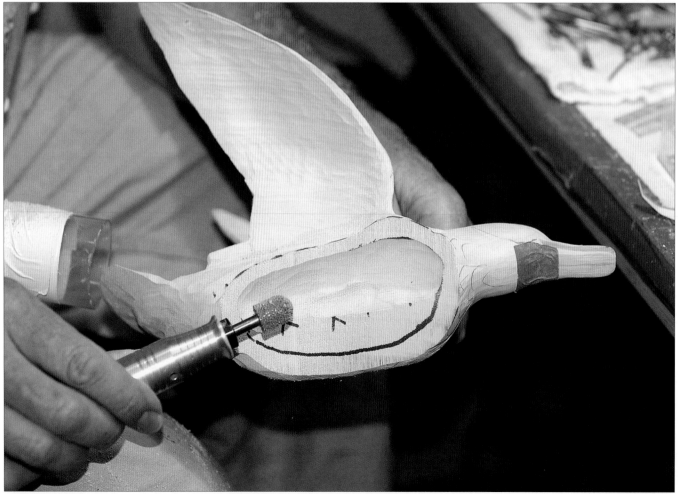

I take my time hollowing the body cavity. Minimizing weight is my overriding concern at this stage of the carving process.

The body is now hollowed out. I will glue the panel back on and carefully smooth the joint, as I smoothed the joints on the falcon.

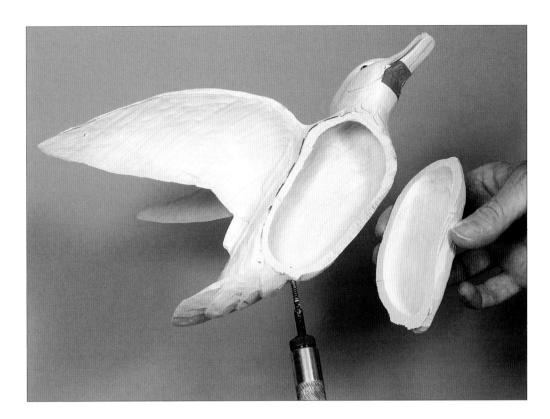

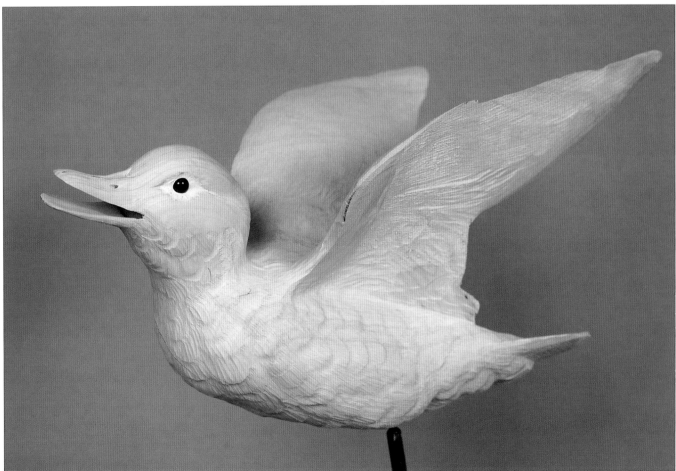

The teal has now been fully contoured throughout the body and I've placed the eyes. Now it's time to work on feathering the open wings.

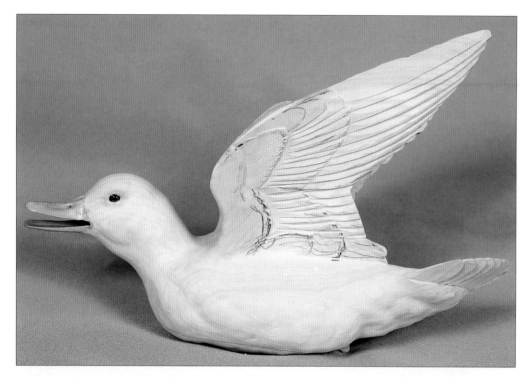

Here are the wing feathers all laid out and ready for a lot more carving. I've also begun adding color to certain finished parts of the anatomy.

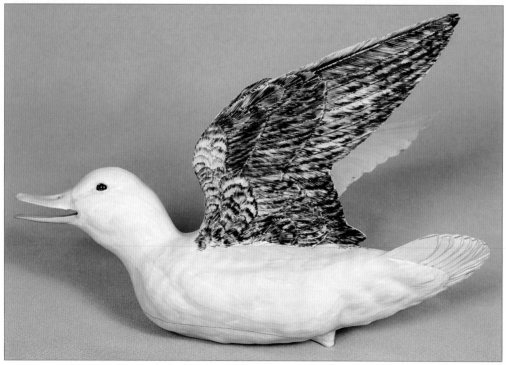

The underside of the left wing has now been fully textured with a burning pen set at medium heat.

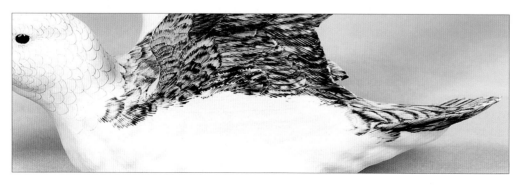

The burning continues onto the top of the tail.

I'm beginning to texture detail on the forehead area with a burning pen. Typically, the head feathers are deeper, finer, and denser than the overall body contour feathers, so I burn them a bit darker and tighter. To do this, I'm using a sharpened spade-shaped burning tip.

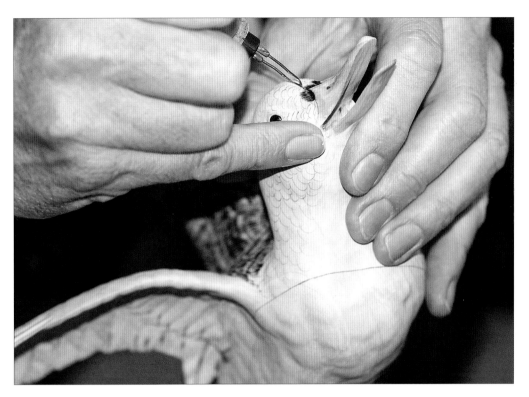

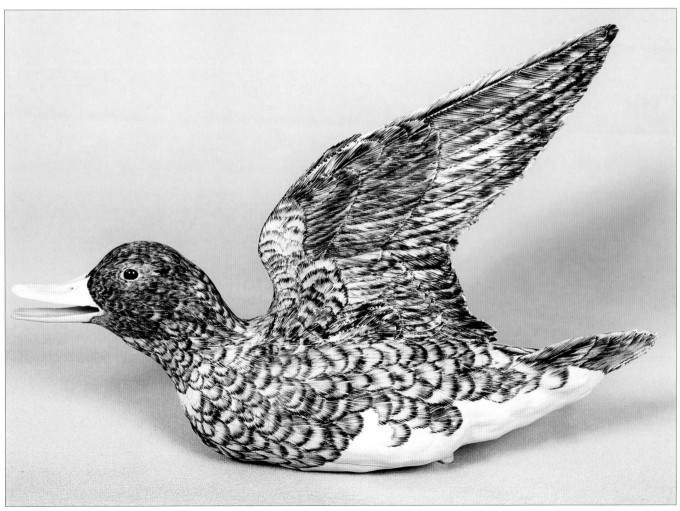

Burning the teal was much easier and took less time than it did for the much larger falcon.

This shot of the teal's right side shows how the wood burning progresses towards the back.

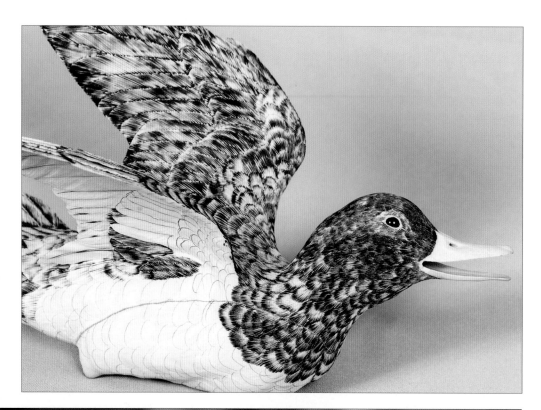

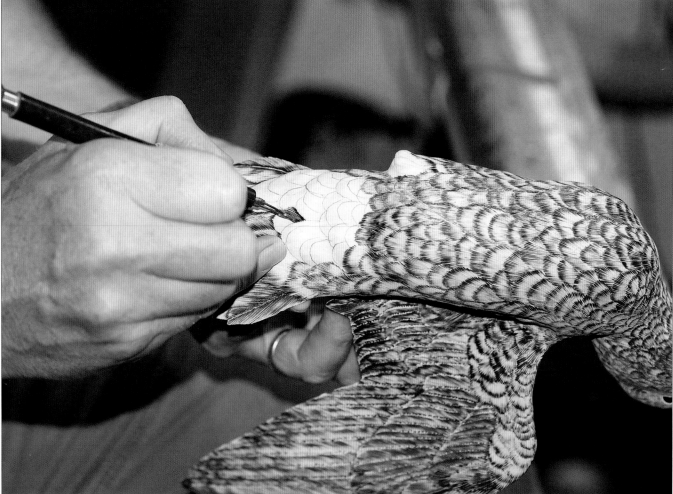

I wrap up the burning detail on the under-tail coverts. The finish line is near!

Applying gesso is always a happy time indeed! I love to paint! I'm using a $^3/_4$" oval wash brush, with the white gesso thinned down to about the consistency of skim milk. I keep it thin for all the burned areas because I want to avoid any buildup that might clog the fine texturing.

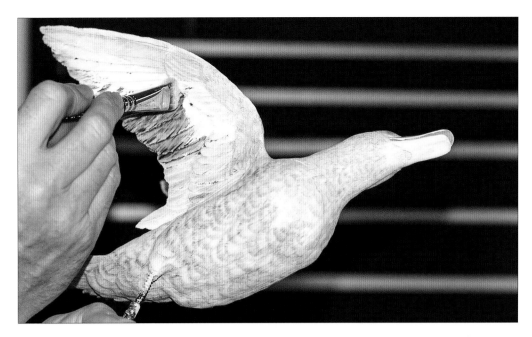

In order to attach the teal to the falcon, I must cut off the toes of the falcon's left foot. I will attach it to the belly of the hapless duck.

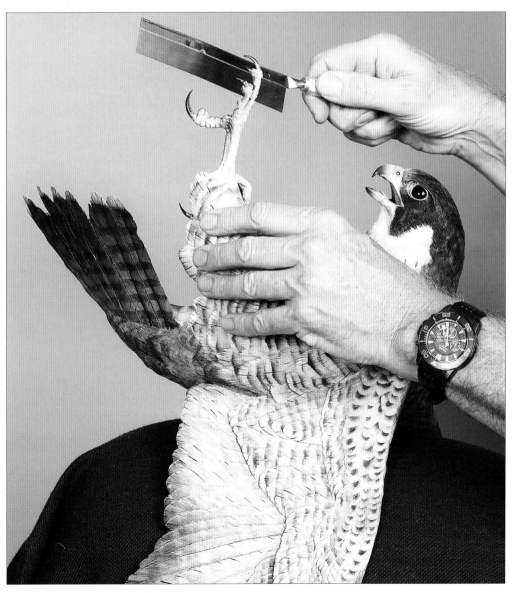

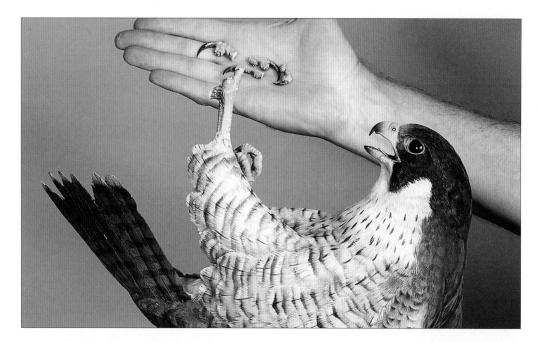

The "toeless" peregrine falcon.

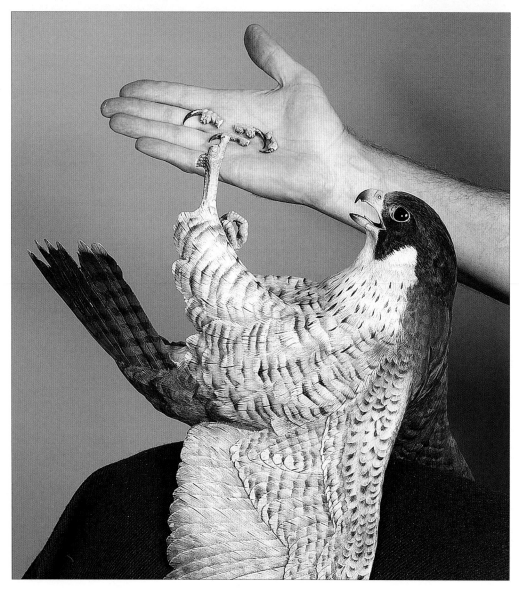

I test fit the teal to the falcon after I have removed the toes.

After deciding where the falcon's toes will set into the teal's breast, I attach the foot with epoxy putty and blend the duck's breast feathering up onto the toes.

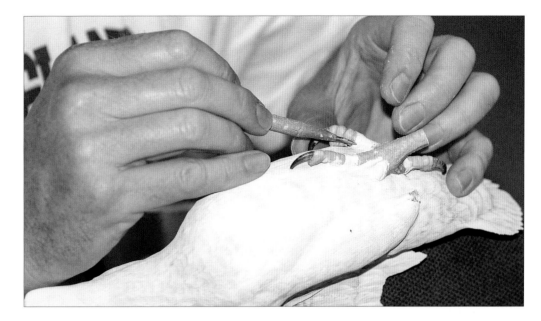

The completed attachment.

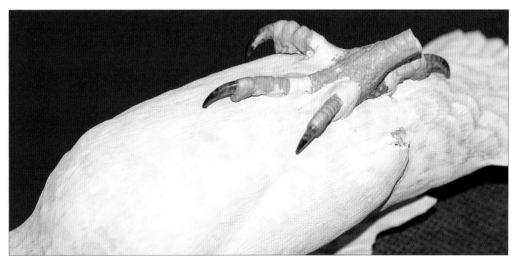

The teal's neck required some additional work. I decided it was just too fat and needed some slimming down, which I did with the Foredom tool and medium-grit sanding sleeve. Sometimes you have to go back and redo certain areas. Trust your instincts about this. If it doesn't feel right . . . it probably isn't. Don't be afraid to make changes even at an advanced stage in the carving. You are the master!

I sand out the neck area with 400-grit wet/dry paper for optimum smoothness as I prepare it for retexturing.

I lay out the feather flow around the neck and then texture the feathers. I'm careful to try to match exactly the surrounding texturing to create an invisible joint.

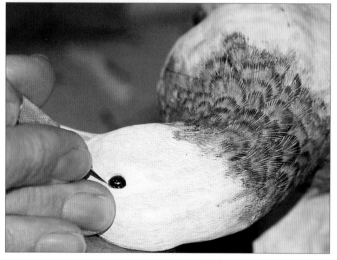

After the gesso has dried I clean off the eye, using an X-acto knife with a #11 blade. Sometimes it helps to dip the point in water and then begin peeling away the dried paint covering the eye.

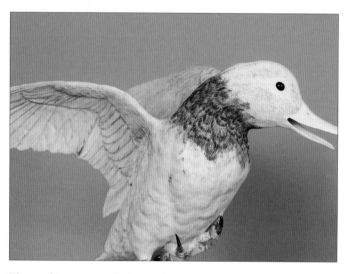

The teal is now ready for sealer and paint. Although most of the body has already been sealed and gessoed, I will go back over areas that have been redone or fixed with another layer of gesso to be safe.

This is my blank canvas awaiting the application of color!

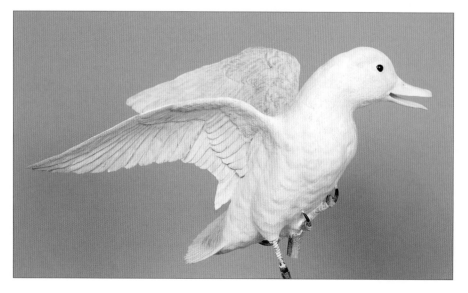

The green-winged teal as paint is applied.

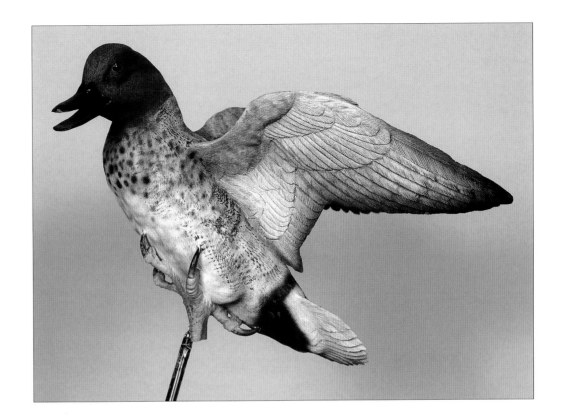

I cross-check the color and plumage against the real duck.

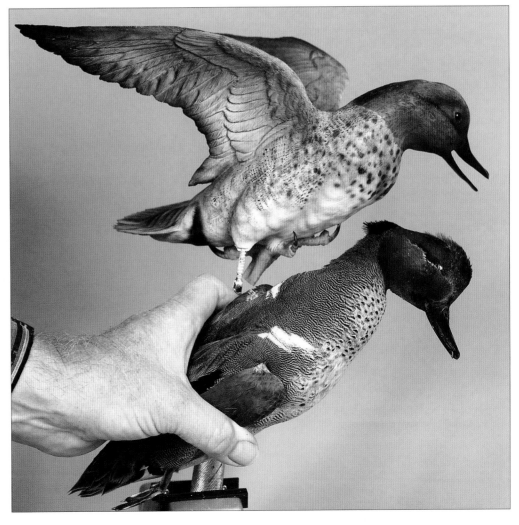

W ho knows why so many birds (especially the males) have evolved such dazzling and complex wardrobes? What I do know is this. As artists, it's our job to try to creatively recreate this visual traffic jam of colors, shapes, and textures with a few basic tools and paint. Not a lot of paint, but with a lot of painting...and there lies the difference!

Few North American waterfowl challenge our skills with a brush more than the drake green-winged teal. As with the falcon, the whole process of painting the teal becomes less daunting if you break down the individual areas to their simplest elements. Prior to the application of any color, give the entire duck up to four thin coats of white gesso thinned to the consistency of skim milk and applied with a ³/₄", good-quality oval wash brush. Be absolutely certain that each layer is totally dry before you apply the next. Your goal is to achieve an overall consistent whiteness with some of the brown tones of the wood burning still slightly visible.

Paint the top surfaces of the wings with up to three thin wash coats of a mixture of 50% white, 40% raw umber, and 10% ultramarine blue. Deepen the color of the outer edges of the wings with a mixture of 80% raw umber and 20% ultramarine blue. The brilliant green speculum found on the midsection of the secondaries is 50% ultramarine blue mixed with 50% cadmium yellow. Once this is dry, I wash iridescent green over the area to visually wake it up. All the fine "squiggly" vermiculation is painted in with a fine, pointed #1 sable detail brush.

I create the soft-looking gray of the underwings with multiple thin wash coats of 50% white gesso, 40% raw umber, and 10% ultramarine blue. The outer edges are darkened with 50% raw umber and 50% ultramarine blue. Then I go back over and dry brush the overall feathers with pure white.

The rich chestnut brown, coppery color of the head is just multiple thin washes of burnt sienna with a touch of yellow oxide. I airbrushed the beak with a mixture of 50% burnt umber and 50% ultramarine blue finished with two coats of satin polyurethane. The green eye patch is Hooker's green and the fine border is raw sienna.

The tail gets several thin washes of raw umber bordered by unbleached titanium. The central area is 50% burnt umber and 50% ultramarine blue with the fine edges painted in with a #1 pointed sable brush.

All the finishing details such as the airbrushed breast spots, feather splits, and additional vermiculation markings are 50% burnt umber and 50% ultramarine blue. The breast area received a thin wash of raw sienna.

The green-winged teal as painting progress is made.

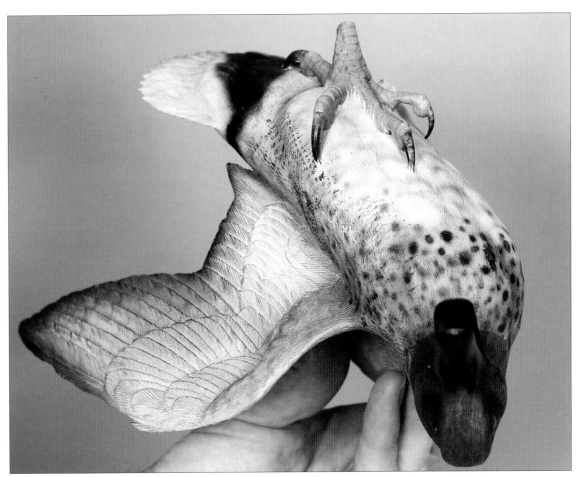

I spent a great deal of time on the foot attachment because I wanted to show the depth of the teal's breast feathering as the talons are plunged into the breast. Using additional A+B Putty and a wet index finger, I blended the soft belly feathers of the teal up and onto the deadly toes and talons of the falcon. This interplay created a really nice visual effect.

The author puts in the final touches on the under-tail coverts and breast feathering using a #6 detail sable brush. This stage can drive me crazy as I keep seeing areas that need additional work.

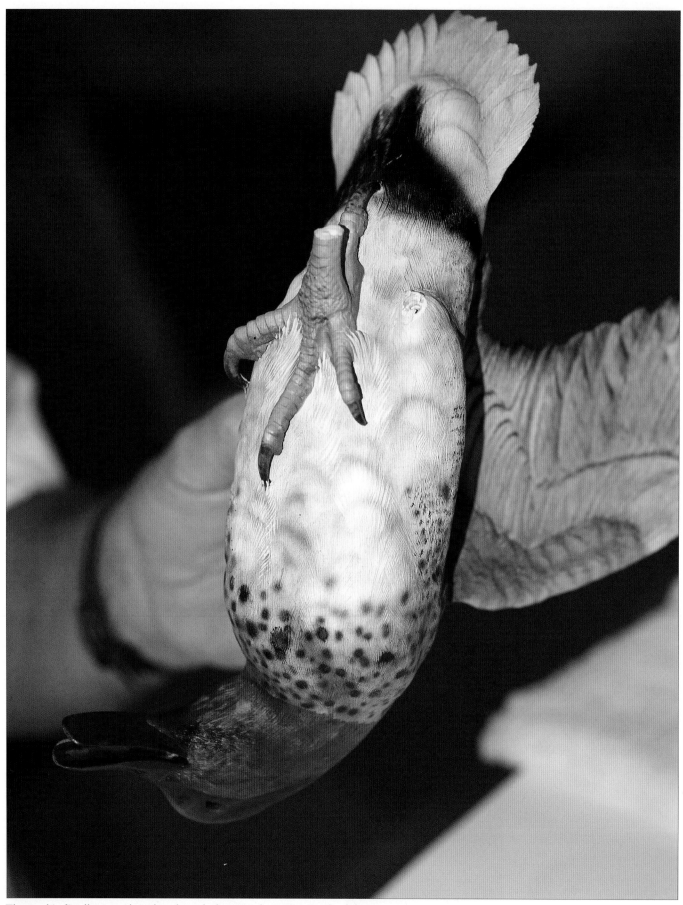

The teal is finally completed and ready for attachment onto the falcon.

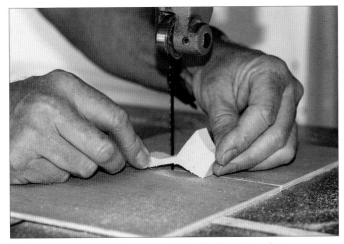

I will carve the teal's feet out of the lightest tupelo I can find in my shop. Weight is an important factor, which is why I didn't use any metal.

I'm cutting the feet thinner. Notice the plywood I'm using for greater stability and accuracy in my cut. You must use great care when doing this kind of band saw work.

Two teal feet are ready for detailing.

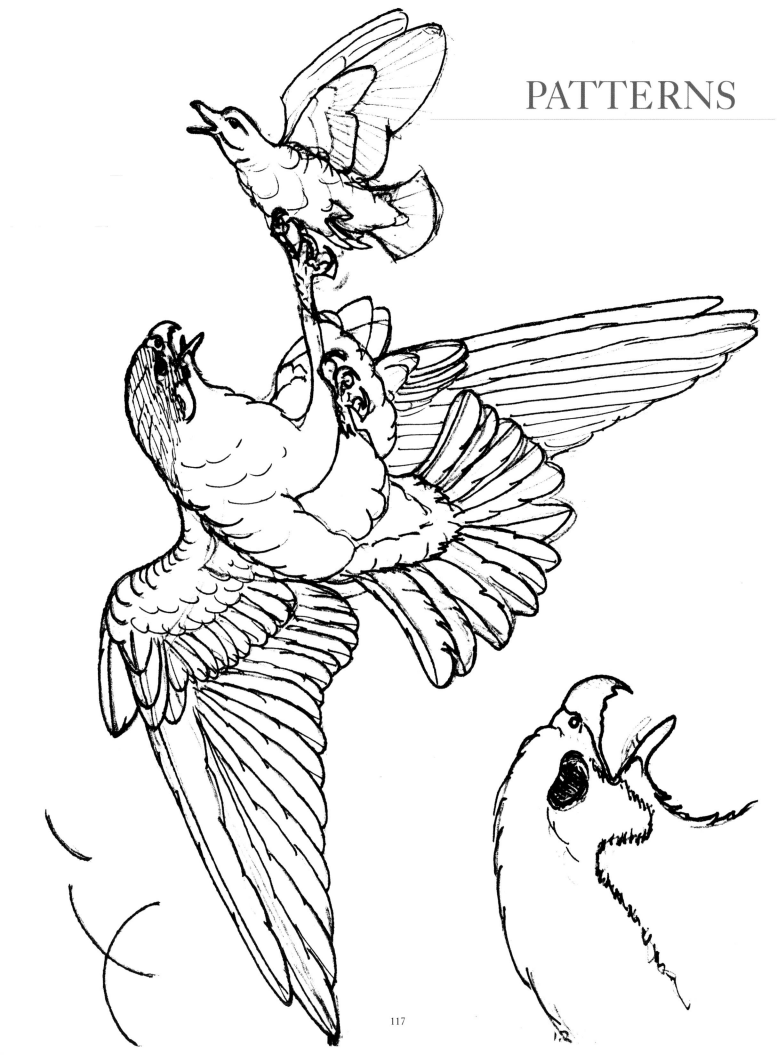

... So... You want to carve a Peregrine ? Start with a sitting bird.
Here's some information to help you along the way !

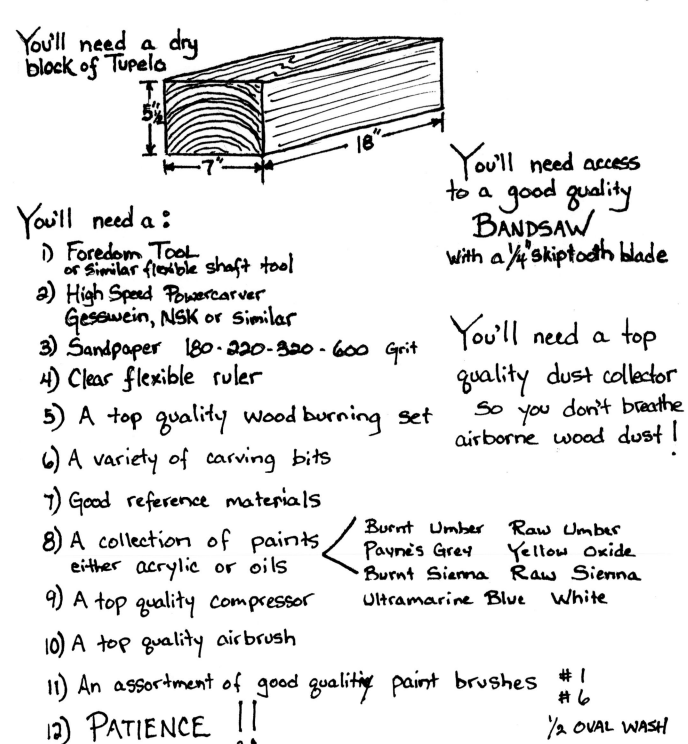

You'll need a dry
block of Tupelo

5½"

7"

18"

You'll need a :

1) Foredom Tool
or similar flexible shaft tool

2) High Speed Powercarver
Gesswein, NSK or similar

3) Sandpaper 180·220·320·600 Grit

4) Clear flexible ruler

5) A top quality wood burning set

6) A variety of carving bits

7) Good reference materials

8) A collection of paints
either acrylic or oils

9) A top quality compressor

10) A top quality airbrush

11) An assortment of good quality paint brushes #1
#6

12) PATIENCE !!

You'll need access
to a good quality
BANDSAW
with a ¼" skiptooth blade

You'll need a top
quality dust collector
So you don't breathe
airborne wood dust !

Burnt Umber Raw Umber
Payne's Grey Yellow Oxide
Burnt Sienna Raw Sienna
Ultramarine Blue White

½ OVAL WASH

— PEREGRINE FALCON FACT SHEET —
Notes from Floyd's Studio

GRAIN DIRECTION

BALANCE POINT

PEALE'S PEREGRINE FALCON
PROFILE PATTERN
½ SCALE

PEALE'S PEREGRINE FALCON
BACK PATTERN
½ SCALE

PEREGRINE FALCON HEAD PATTERNS
"Peale's falcon"

TOP OF HEAD ACTUAL SIZE

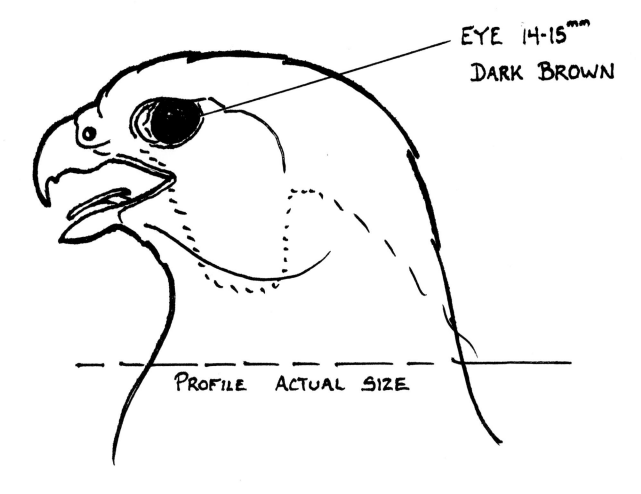

EYE 14-15mm
DARK BROWN

PROFILE ACTUAL SIZE

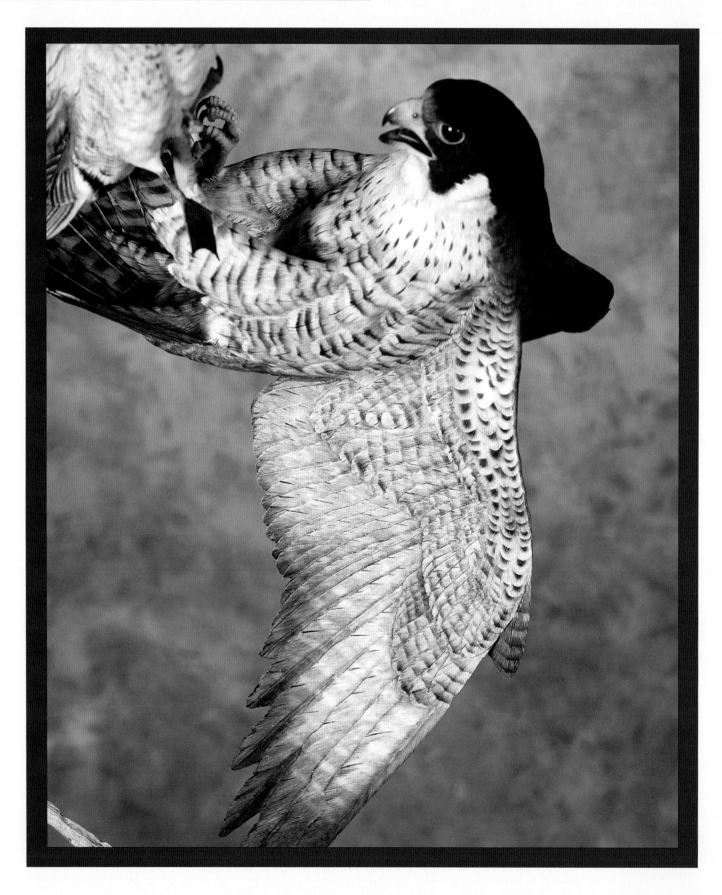

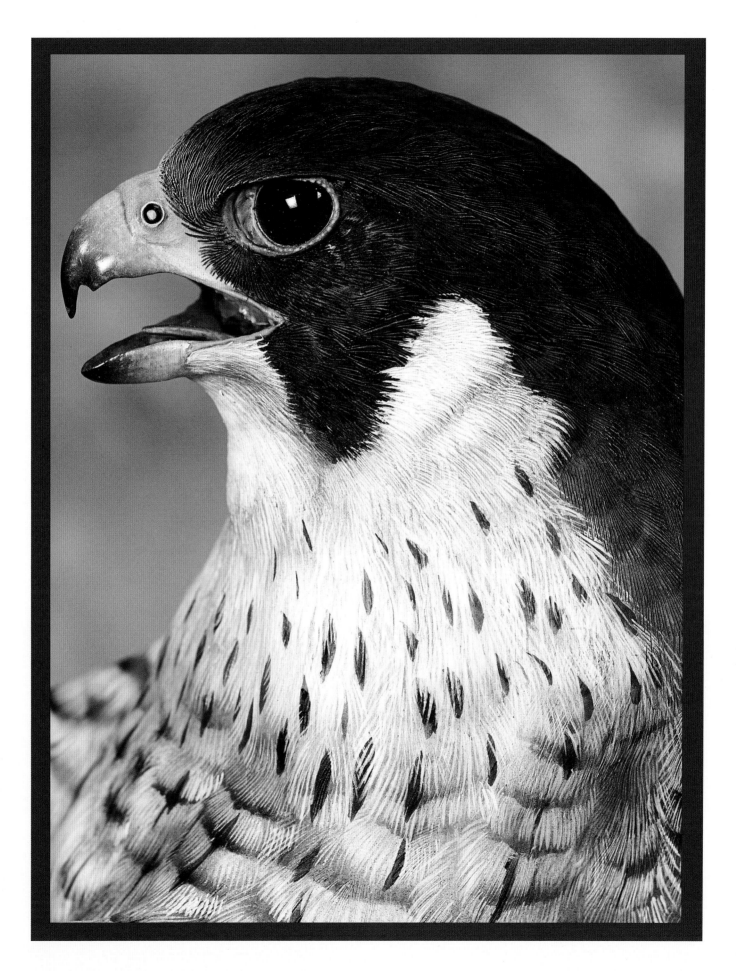

PEREGRINE FALCON

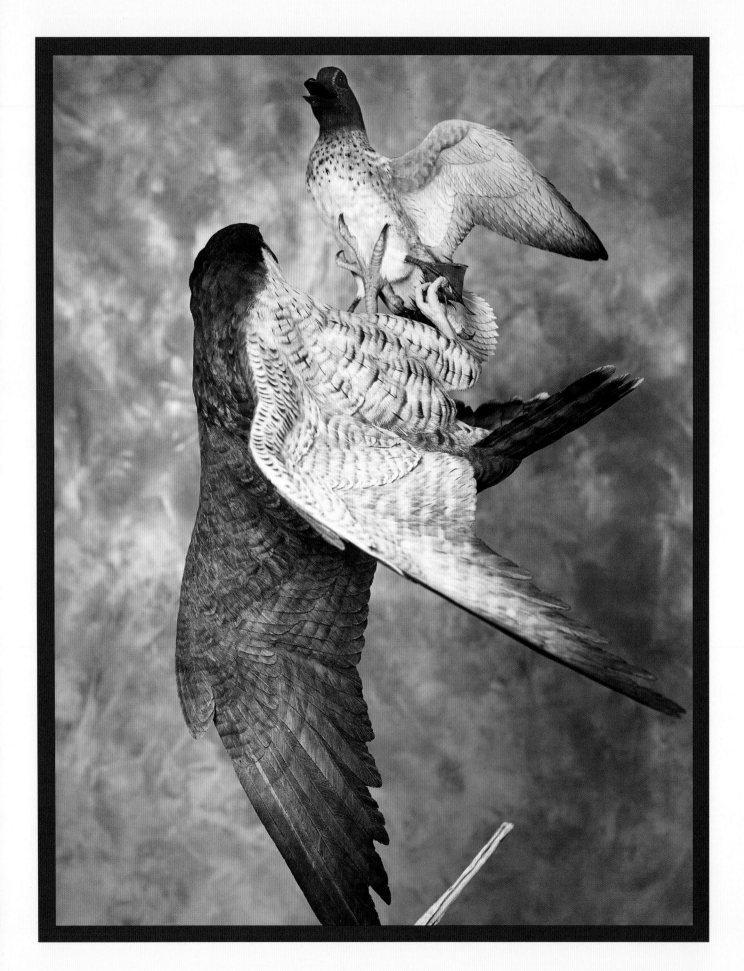

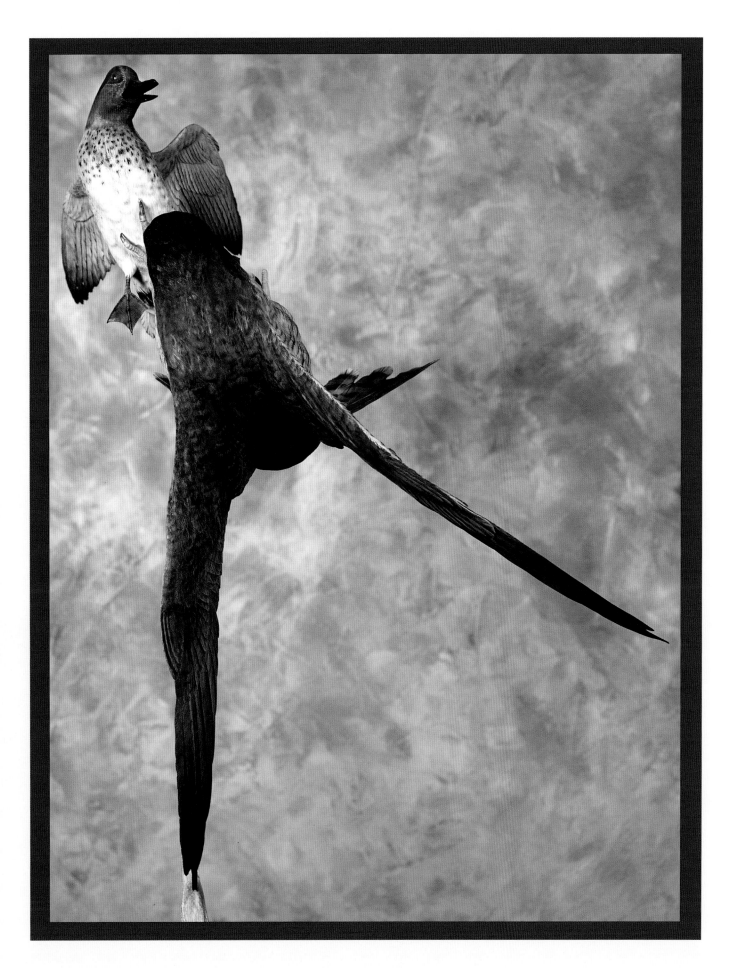

PEREGRINE FALCON

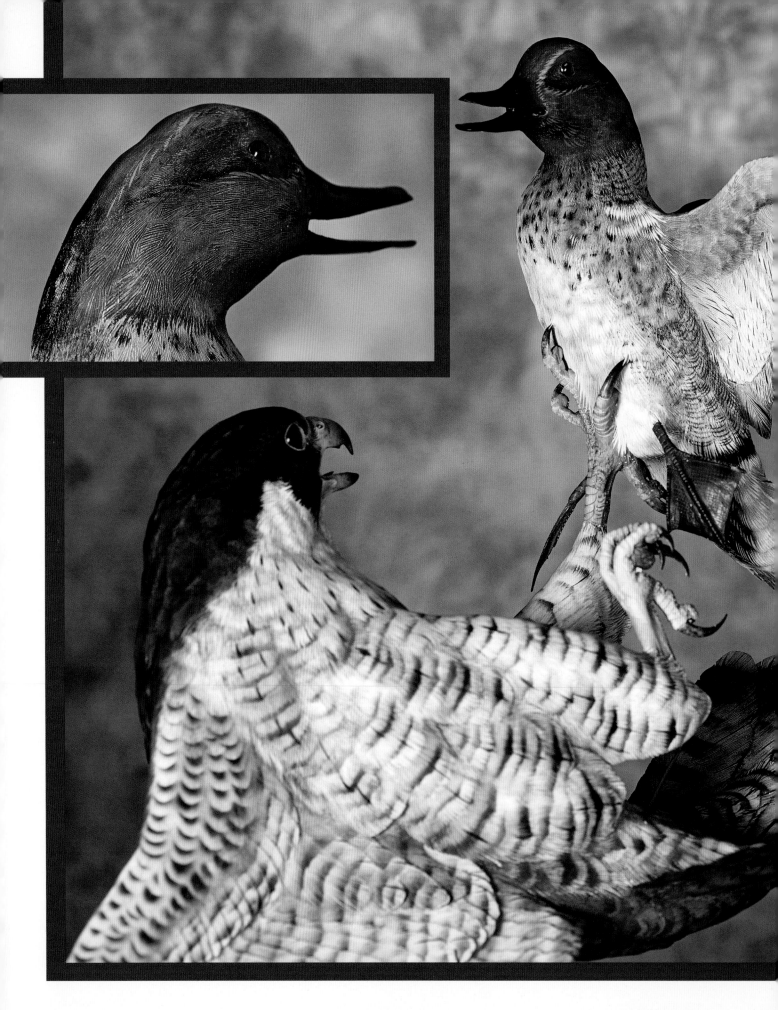

PEREGRINE FALCON

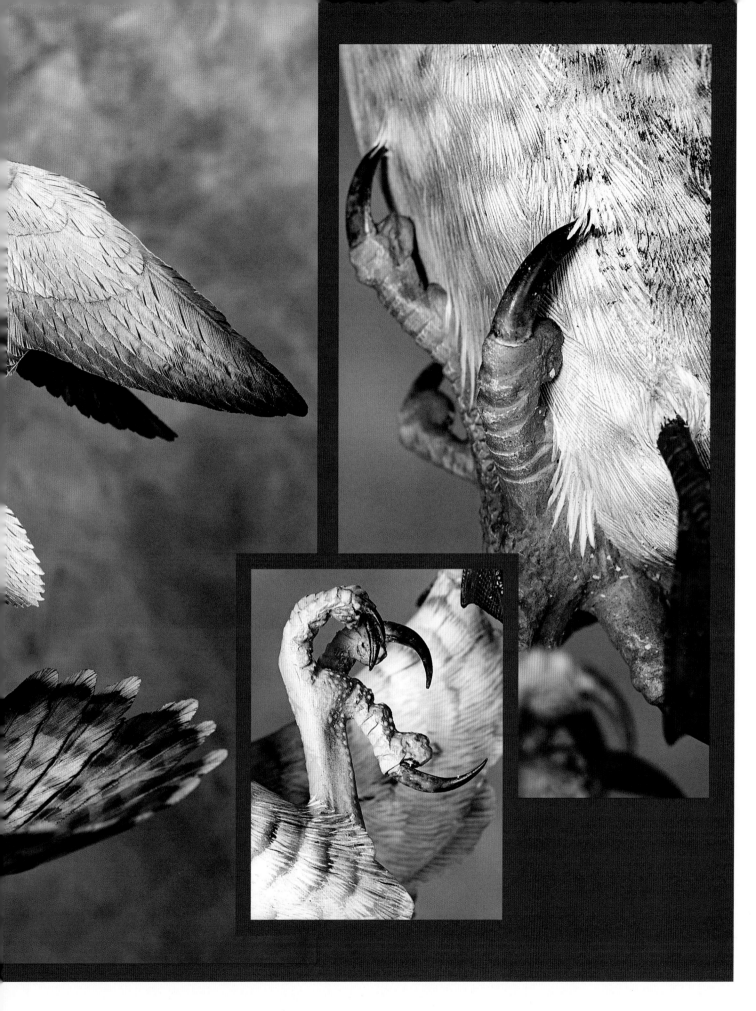

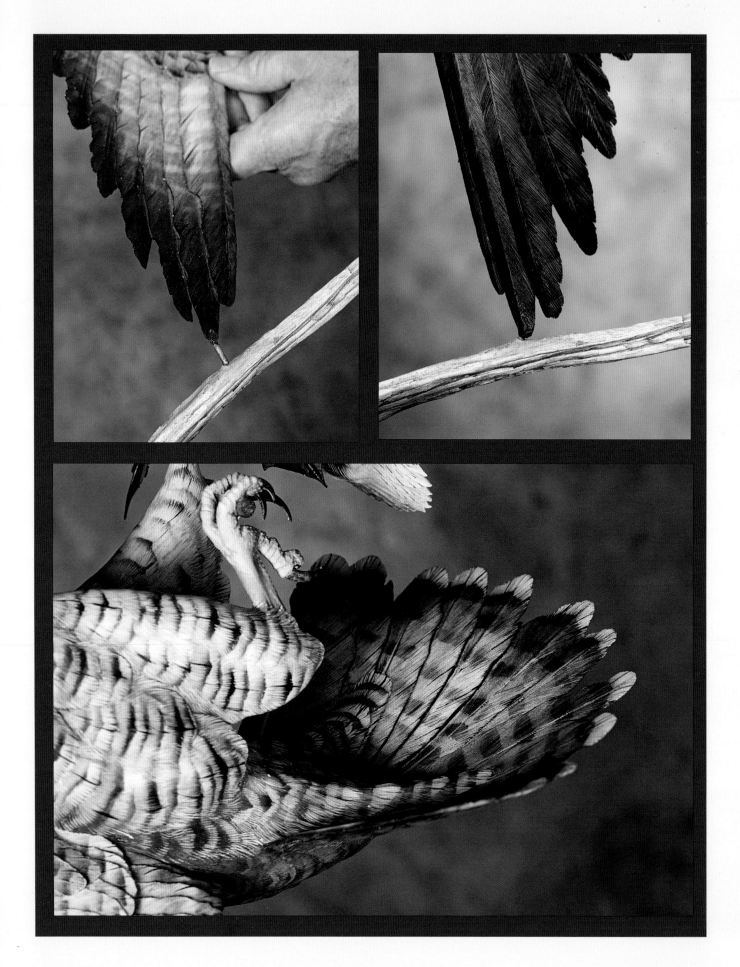

The Commission

It seems everyone, regardless of cultural background, has a story to tell about birds. There are few places in the world where you cannot step outside and see or hear a bird within a minute or two. So elusive, yet so familiar—that's the paradox of birdlife.

Humans can only dream of unaided flight, so the skies and clouds seem an irresistible playground. We envy birds when they suddenly take flight, something we can do only with the aid of loud machines or cumbersome hot-air balloons. For thousands of years before the invention of balloons and airplanes, humans could only imagine the view from above, unable to know what it feels like to ride the wind. No wonder birds fascinate us.

Considering my own fascination with birds, it makes sense that I became interested in falconry. It seems so unlikely that earthbound humans can partner with one of nature's most perfect aerial predators to stalk and hunt. Yet the partnership has worked for thousands of years.

Early fall I conduct my annual carving and painting seminar up in Gwinn, Michigan. My dear friends Jim and Pam Krausman host the event and it's something I look forward to every year. I get to travel to a beautiful part of the country and focus solely on the art of bird carving with a nice group of artists.

Quite unexpectedly, in 2012 one of my students approached me with an idea and offer that caught me totally by surprise. My friend Dr. Robert Rankins, a master falconer, shared a story of a special day in the field when he witnessed the amazing aerobatics of his prized peregrine falcon, Thumper. He wanted me to capture in wood what he had experienced that day. I was moved by Robert's account of that incredible encounter and felt honored to have the chance to bring it to life in a carving.

Here is his story.

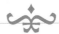

At the time of the fabulous flight, Thumper (my peregrine falcon) was a four-year-old intermewed Peale's peregrine from a breeding program in British Columbia. I acquired her when she was 10 days old and I flew from Dallas, Texas, to Seattle and rented a car to complete my journey. We spent our first night together in a hotel room, where I had placed her in a dresser drawer lined with paper on the floor. She paced around the box on and off all night. To me it sounded like someone thumping the drawer bottom. That's why I named her Thumper.

She grew into a delightful bird and hunting companion. She had a natural liking to get a decent pitch, although rarely above 800 to 900 feet. I trained her early on with pigeons and then she graduated to bagging mallards.

At this time we hunted on several large ranches north of Dallas. They had numerous ponds, ranging from one acre to less than $1/8$ of an acre in size. Most all the ponds were visible from the roads we used so when I spotted any unsuspecting ducks I would quietly slip from the truck and release Thumper into the air. Then I would hastily make my way down to the pond.

The flight that Floyd immortalized with the work featured in this book took place in November 1994. As I noted in my journal, it was a cool, blustery morning when I spotted six green-winged teal on a pond.

Green-winged teal are notoriously difficult to hunt with a falcon. The ducks will simply fly fast and low from one end of a pond to the other and never leave the water's safety, making them impossible targets for an eager falcon. But this particular pond was one of the smallest ones, giving Thumper an opportunity.

I launched Thumper into the air and she quickly and steadily climbed to about 800 feet and set her wings. As she drifted upwind of the pond, I ran and flushed the flock of teal. All six rose and flew downwind as Thumper began her stoop (dive). Just about the time she had descended to 150 feet above the water in hot pursuit of the flock, the teal turned sharply and headed back into the center of the pond in a counterclockwise arc.

I stood about 15 feet from the edge of the water and watched the drama unfold. Thumper had selected a teal on the outside of the flock. The other five made sharp dives for the surface of the pond. As Thumper closed the gap on the straggler, the duck turned and flew directly at me.

Thumper made one last powerful thrust with her wings to get within striking distance. Suddenly and unexpectedly, she rolled over on her back, flew under the teal, and buried her sharp talons into the duck's soft belly. Tumbling through the air in a tornado of wings and feathers, Thumper regained control of her flight and landed with her prize three feet from the water's edge.

It was one of the most amazing flights I will ever witness as a falconer.

Over several years we hunted in Texas, California, and North Carolina. Thumper grew into a supreme hunter and companion and would consistently catch two or three ducks on each outing. Sadly, she herself fell prey to a far more formidable predator in 1998 when she crossed the path of a hungry golden eagle. She was $8^1/2$ years old.

I buried her in a teak casket on my farm in Melissa, Texas. While her remains rest in a special place near my new home, her legacy will forever be celebrated in the form of a master carving I commissioned from Floyd Scholz of Hancock, Vermont. The sculpture honors that magic moment I witnessed on a brisk November morning by the side of a small pond in Texas.

Robert Clifton Rankins III

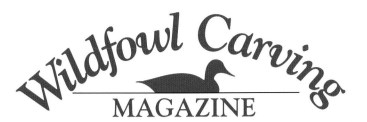

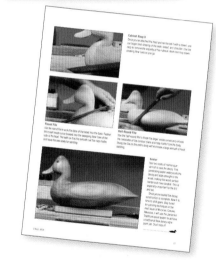

IN MEMORIAM

"Forever"
A Poem of Remembrance

It's the finality of "Forever" that stings the sharpest.
Saying a final goodbye to friends means certain things in life have changed…forever.
Close friends who've inspired, and whose works I've admired, are now gone…forever.
There's some comfort in knowing, through those they've touched, and the work they've done
Their spirit will carry on…forever.
Words can't ease the pain, only time can soften.
To my departed friends I can only say,
I miss you, you're thought of often.
This troubled world is a better place, because you all were in it.
You shared your gifts, you left your mark,
And that will last…forever.

Floyd Scholz
Hancock, Vermont, November 10, 2013

TAD MERRICK: Photographer, musician, and my close friend and associate for over 30 years.
Tad's "awe shucks" manner belied his insightful professionalism and pursuit of excellence in all he did. Tad's contributions to my first five books were invaluable.

BOB GUGE: Unquestionably one of the greatest and most influential bird carvers the world has known.
We are all better bird carvers because of Bob.

TOM MONAHAN: Singer, guitarist, songwriter, woodworker, funnyman and philosopher.
Where does one begin to describe this Renaissance man who made everyone around him feel a little better about…well…everything?

MURRAY SINCLAIR, THE "KING OF BAY STREET": My dear friend: "We're not here for a long time, so let's be here for a good time."
Murray moved mountains. His love for the best that life had to offer was rivaled only by his unmatched gusto for enjoying it with his family and friends. His awe, enthusiasm, and admiration of nature, wildlife art, and those who created it were contagious.... . He will be greatly missed.

BILL BALLARD: With a generous heart and spirt as big as Georgian Bay, Bill was a person who truly loved beauty in all forms.
Saying a final goodbye to my friend Bill Ballard of Toronto, Canada, this year is particularly tough. When he discovered something special, his unabashed joy came from sharing it with others. Beneath his rough and at times gruff exterior, beat a compassionate and warm heart. Taken away much too soon.

BIOGRAPHIES

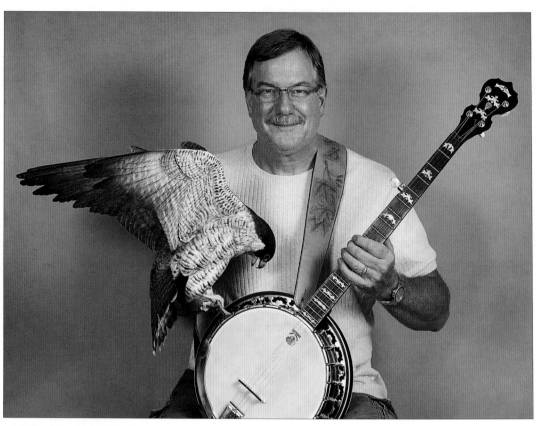

A professional artist/carver since 1983, Floyd Scholz is universally recognized as one of the preeminent woodcarvers and painters in the world today. He is a five-time U.S. National Champion and the 2005 World Master's Best in Show Champion. His work has been included in the prestigious Leigh Yawkey Woodson Art Museum's "Birds in Art" exhibition and in the collections of the Walt Disney Corporation, Sprott Asset Management Toronto, Pine Tree Capital Toronto, the Smithsonian Institution, and Cornell University. His work has also been featured in many publications, among them *Forbes*, *Living Bird*, *Fine Art Connoisseur*, *Guitar Player*, *Smithsonian Studies in American Art*, and *People*. As the author of five award-winning books on raptors, including *Golden Eagle: A Behind-the-Scenes Look at the Art of Bird Carving*, Scholz has shared his passion for birds and love of art with a worldwide audience. In 2014 the Ward Museum of Wildfowl Art in Salisbury, Maryland, named Floyd one of its "Living Legends."Scholz enjoys the drama, grace, and mystery of birds of prey and he has spent thousands of hours observing hawks and eagles in the mountains near his home, watching them as they interact with their environment. His sculptures depict the birds in a highly animated way, capturing the sense of action and high drama he sees in the wild.

Floyd plays and endorses Deering Banjos!

Ellyn Siviglia is an award-winning professional photographer who opened Lasting Impressions by Ellyn, a portrait and design studio in Windermere, Florida, in 1999. Her photographic subjects have included Supreme Court Justice Sandra Day O'Conner, celebrities, professional basketball and baseball players, and even the baby next door. Her work has appeared on Oprah and in several magazines. Her love of art, beauty, and nature has combined with Floyd's carvings to give her a new perspective to explore with her camera. She and Floyd have worked on many projects together in the past, making *Peregrine Falcon* an easy collaboration. She says it's been an honor to work on this book with Floyd, whose friendship she values greatly.

133